LEARN TO DRAW

STAR WARS™

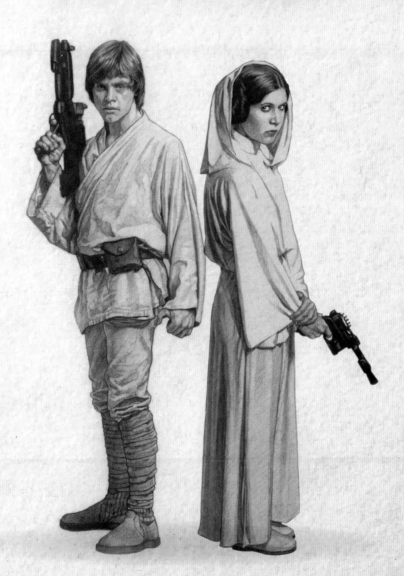

Walter Foster

Step-by-step artwork and text by Russell Walks.
Photographs and text on pages 4–5 © Elizabeth Gilbert,
and pages 6–7 © Jacob Glaser.

Published by Walter Foster Publishing,
an imprint of The Quarto Group
6 Orchard Road, Suite 100, Lake Forest, CA 92630

Printed in China
1 3 5 7 9 10 8 6 4 2

MIX
Paper from
responsible sources
FSC
www.fsc.org
FSC® C016973

Table of Contents

Tools & Materials

Graphite pencil is a great starting point for a beginning artist. All you really need are a few basic tools, including the right paper and a few different types of pencils.

Drawing Paper

Paper can vary in weight (thickness), tone (surface color), and texture. Start out with smooth, plain white paper so you can easily see and control your strokes. Also, use a piece of paper as a barrier between your hand and your drawing. This prevents you from smudging your drawing and keeps oils from your skin from damaging the art.

Pencils

Graphite pencils are labeled with numbers and letters—and the combination of the two indicates the softness of the graphite. B pencils, for example, are soft and produce dark, heavy strokes, whereas H pencils are harder and create thin, light lines. An HB pencil is somewhere in between the two, which makes it a good, versatile tool for most artists. For the projects in this book, begin with a basic #2 pencil and a 4H pencil.

Holding a Pencil

There are two common ways to hold a pencil: the underhand position (A) and the writing position (B). The underhand position is great for loose sketches, shading, and broad strokes, whereas the writing position is ideal for detail work.

A

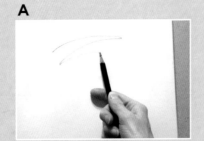

B

Erasers

Erasers remove mistakes, but they are also effective drawing tools in themselves. You can use them to pull out light lines, add crisp highlights, subtly lighten areas of tone, and more. **Vinyl and plastic erasers** are usually white with a plastic feel. They leave behind a clean surface and are gentle on the paper's fibers. **Kneaded erasers** (usually gray) are pliable like clay, allowing you to form them into any shape. Knead and work the eraser until it softens; then dab or roll it over areas to slowly and deliberately lighten the tone. To "clean" it, simply knead it. The eraser will eventually take in too much graphite and need to be replaced.

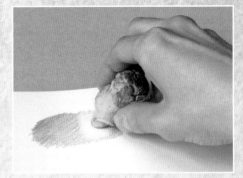

Pencil Sharpener or Sandpaper Block

Sharpening instruments give you control over your pencil tips, which in turn gives you control over the quality of your lines. **Handheld sharpeners** shave pencil ends into cone shapes, exposing the lead and creating sharp tips. A **sandpaper block** is essentially a few sandpaper sheets stapled to a soft block with a handle. Holding the block in place, stroke and roll the pencil tip over the surface to sharpen.

Additional Materials

- Gesso
- Paintbrush
- Toothbrush (to splatter gesso)
- Masking tape
- X-ACTO® knife (craft knife)
- Reading glasses with a powerful correction or a desk lamp with a built-in magnifying lens

Basic Pencil Techniques

With just a few basic shading techniques, you can render everything from a smooth complexion to a simple background. Shade evenly in a back-and-forth motion over the same area, varying the spot where the pencil point changes direction. Don't shade with a mechanical side-to-side direction, with each stroke ending below the last, as this can create unwanted bands of tone throughout the shaded area.

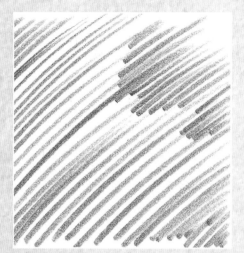

Hatching Make many parallel strokes close together.

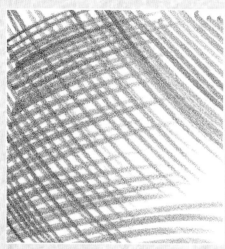

Crosshatching Add another layer of hatching at an angle.

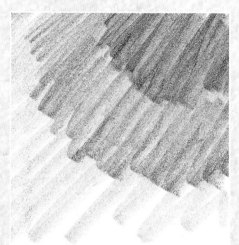

Gradating Apply heavy pressure with the side of your pencil, and then gradually lessen the pressure as you stroke to create a transition from light to dark.

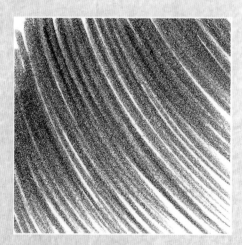

Shading Darkly By applying heavy pressure to the pencil, you can create dark, linear areas of shading.

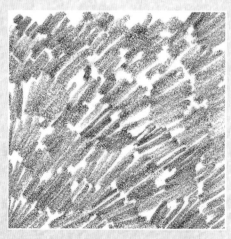

Shading with Texture For a mottled texture, use the side of the pencil tip to apply small, uneven strokes.

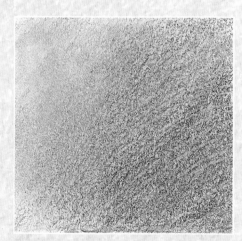

Blending Smooth out transitions between strokes and create a dark, solid tone by gently rubbing the lines with a blending stump or tissue.

Textures

A texture should be rendered based on how the light source affects it. Don't confuse texture with pattern, which is the tone or coloration of the material. Use texture to build a shadow area and give the larger shape its proper weight and form in space. Think of texture as a series of forms (or lack thereof) on a surface. When using this book, you will draw a few different textures, including wood, cloth, hair, and metal.

Wood If left rough and not sanded down, wood is made up of swirling lines. There is a rhythm and direction to the pattern that you need to observe and then feel out in your drawings.

Cloth The texture of cloth will depend on the thickness and stiffness of the material. Thinner materials will have more wrinkles that bunch and conform to shapes more.

Long Hair Long hair, like cloth, has a direction and a flow to its texture. Its patterns depend on the weight of the strands. Long hair gathers into smaller forms—simply treat each form as its own sub-form that is part of the larger form.

Metal Polished metal is a mirrored surface and reflects a distorted image of whatever is around it. Metal can range from dull to incredibly sharp and mirror-like. The shapes reflected will be abstract with hard edges, and the reflected light will be very bright.

STEP ONE: Because Obi-Wan is, in every sense of the word, a hero, our portrait calls for a heroic pose, so begin with a sketch that depicts him in exactly that fashion: hands on hips, feet far apart.

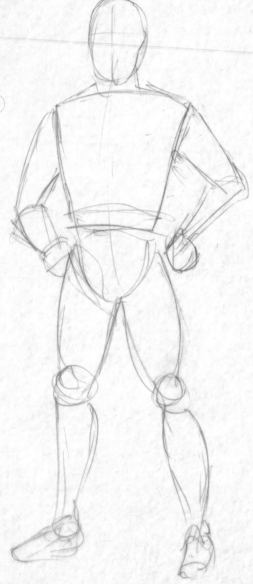

Obi-Wan Kenobi, the legendary Jedi Master, is a noble man and gifted in the ways of the Force. He trains Anakin Skywalker, serves in the Republic Army during the Clone Wars, and guides Luke Skywalker as a mentor. His determination to do what is right never wavers, and it's that determination, as well as Obi-Wan's essential goodness, that the finished portrait should display.

⅃⅃⅃⅃ 2

STEP TWO: Lightly sketch his robe,
which he has pulled back to provide him
easy access to his lightsaber.

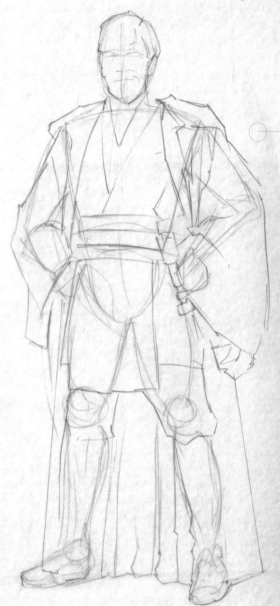

"The Force is what
gives a Jedi his power."

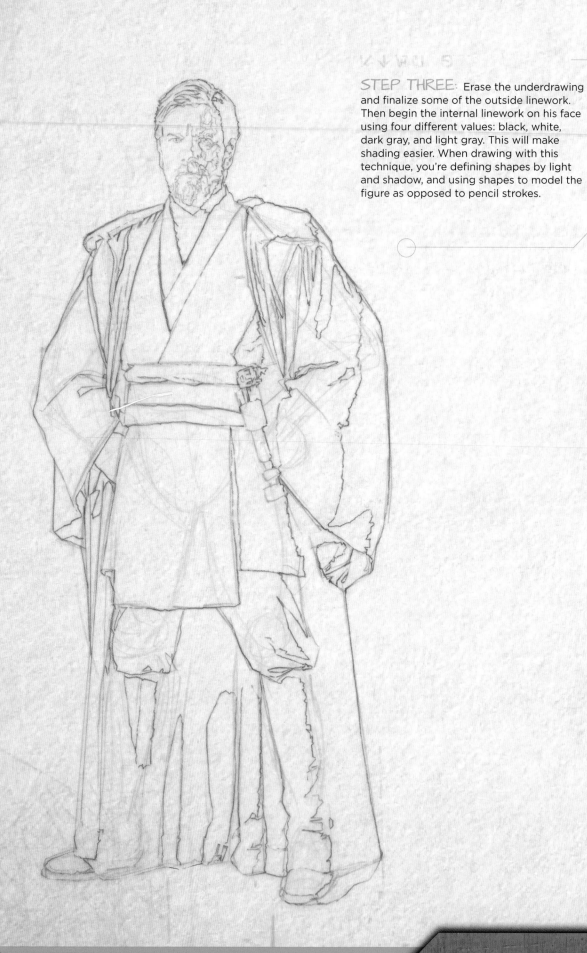

STEP THREE: Erase the underdrawing and finalize some of the outside linework. Then begin the internal linework on his face using four different values: black, white, dark gray, and light gray. This will make shading easier. When drawing with this technique, you're defining shapes by light and shadow, and using shapes to model the figure as opposed to pencil strokes.

STEP FOUR: Outline the internal details of his tunic, robe, boots, and lightsaber using those same four values. Obi-Wan's tunic is ribbed vertically; drawing every one of those ribs would be both time-consuming and needlessly complicated, but it is important to at least suggest them.

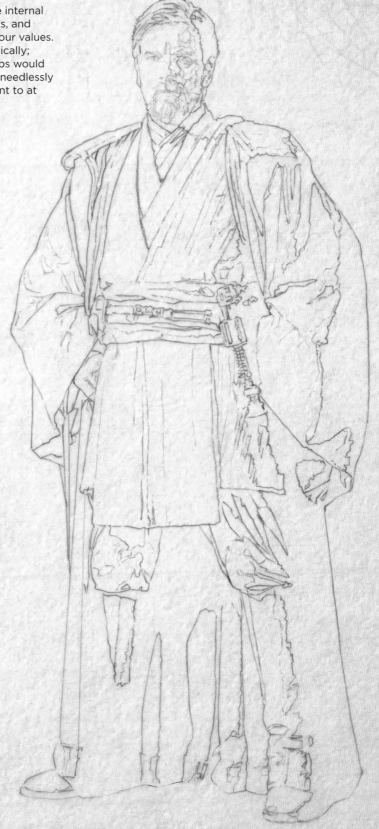

STEP FIVE: Begin adding value to Obi-Wan's hair, robe, pants, and boots. Keep the light source in mind, and remember that it's not essential to exactly duplicate your reference.

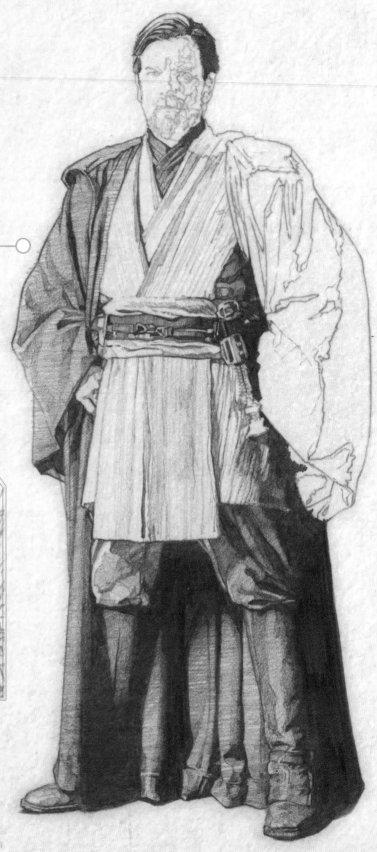

Loose horizontal pencil work portrays the rough material that makes up Obi-Wan's Jedi robe.

STEP SIX: Continue shading. Make sure that the contrast in texture between Obi-Wan's robe and tunic are apparent, and that the drapes and folds in the cloth look realistic. Use coarse horizontal strokes in the robe and softer vertical strokes in the tunic and tabard. The shadows are another issue; you don't want the appearance of cross-hatching, so carefully layer your strokes in the same direction, building up the darks gradually.

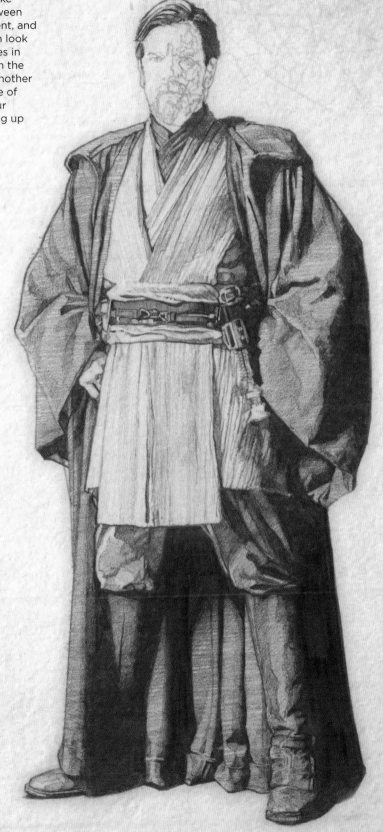

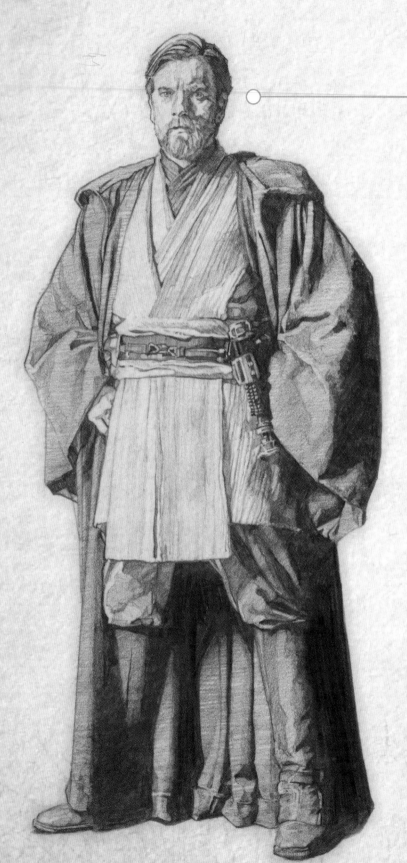

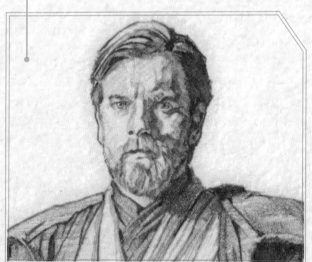

Do your best to keep your pencil strokes consistent and, for the most part, going in one direction. Change the stroke just a bit, however, to emphasize Obi-Wan's furrowed brow.

STEP EIGHT: After some final smoothing
and touch-up—mostly to increase contrast and
emphasize structure—Obi-Wan is ready to help
Anakin meet his destiny. But as we all know, it
does not turn out well for either of them.

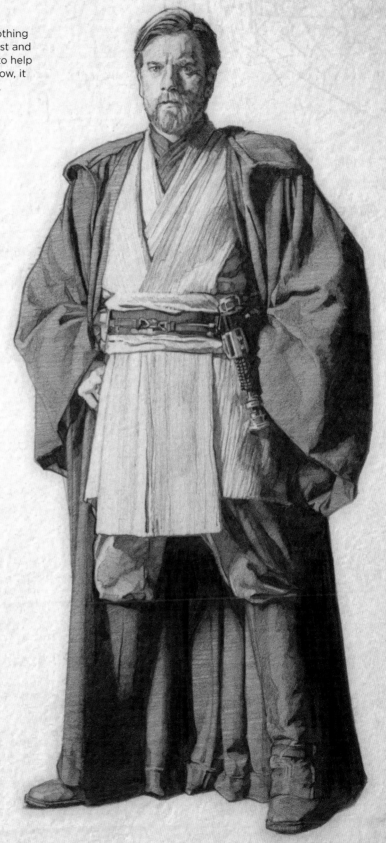

YODA

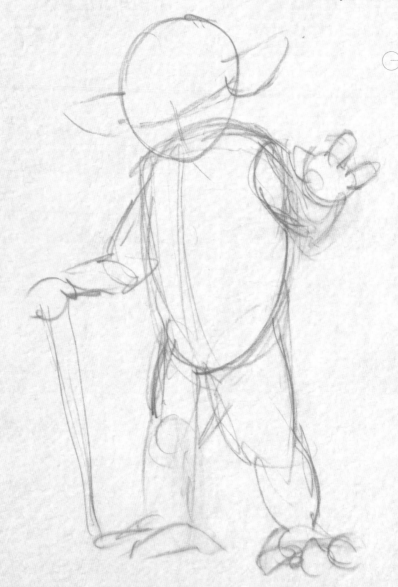

STEP ONE: Yoda's not very big—only about 26 inches, or about a third as tall as Darth Vader. There's a lot of detail in that little package, though. Beginning with a loose sketch, locate and accurately size his limbs, head, and ears in proper proportion to the rest of his body.

Although Yoda is almost 900 years old, his sole concession to age seems to be the cane he leans on as he dispenses wisdom to his fellow Jedi. When called upon to fight, the cane is cast aside, and he becomes a dangerous warrior, as skilled with a lightsaber as he is at diplomacy. The challenge when drawing Yoda is to capture both aspects of his personality; not only the wise sage, but the courageous Jedi as well.

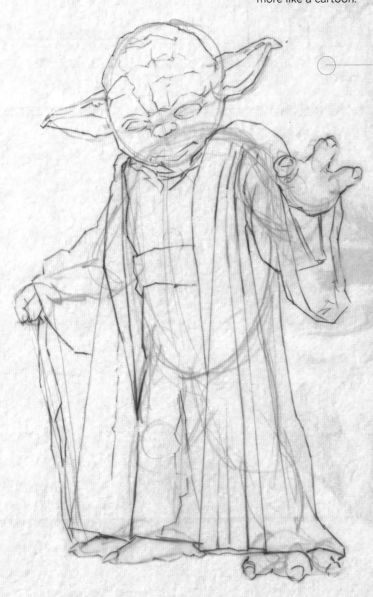

STEP TWO: Tighten things up and rough in Yoda's robe and undergarments. Pay attention to his ears. They're big, of course, but it's important not to exaggerate them, or the final drawing will end up looking less like a portrait and more like a cartoon.

"Do or do not. There is no try."

STEP THREE: Erase most of the underdrawing and tighten up the linework in the face. Draw almost everything you see in your reference, breaking it down by value. Again, make sure that all of Yoda's features are the proper size in relation to one another.

STEP FOUR: Work on the robe, indicating some of its roughness and texture. Spending time on the linework in the early drawing stages will help you to catch the little details that make Yoda seem like a real, living being, as opposed to a cartoon avatar.

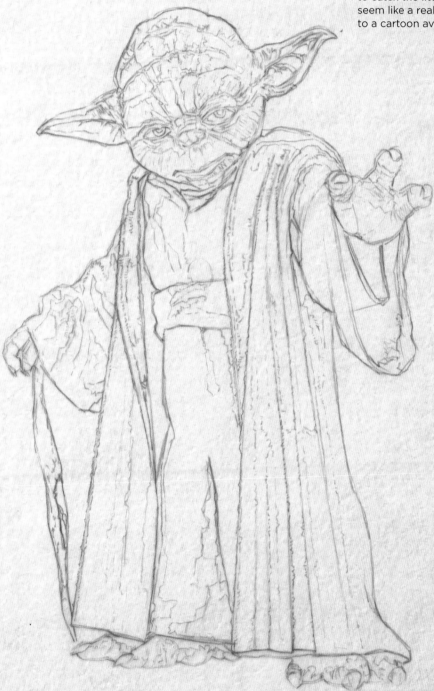

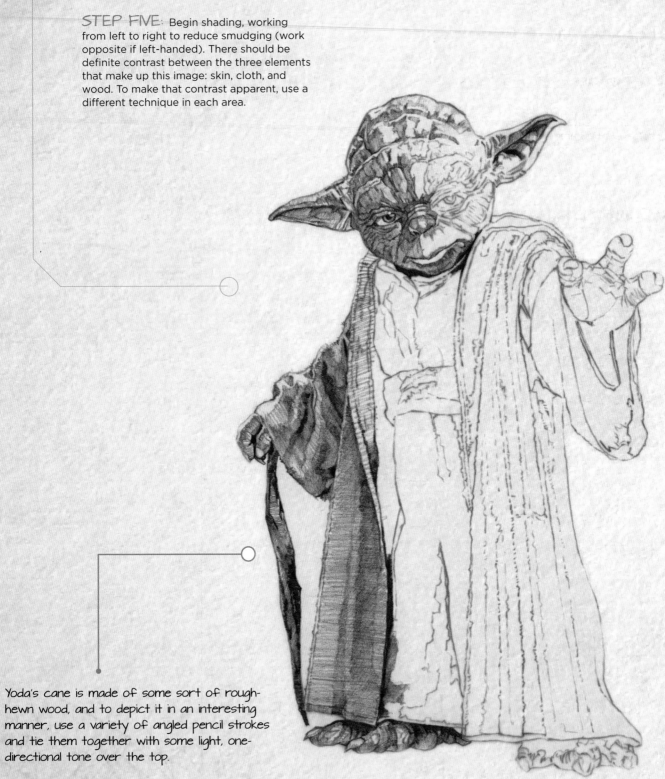

STEP FIVE: Begin shading, working from left to right to reduce smudging (work opposite if left-handed). There should be definite contrast between the three elements that make up this image: skin, cloth, and wood. To make that contrast apparent, use a different technique in each area.

Yoda's cane is made of some sort of rough-hewn wood, and to depict it in an interesting manner, use a variety of angled pencil strokes and tie them together with some light, one-directional tone over the top.

STEP SIX: Use smooth, one-directional strokes on Yoda's face, doing your best to capture both the character's likeness and the wisdom that is evident there. Work in an entirely different manner on the robe: Use choppy horizontal strokes and occasional scribbles. Turn your paper sideways, and use the same technique on Yoda's undergarments. It's evident that this material is softer and less abrasive than the robe, so soften it a bit by applying less pressure.

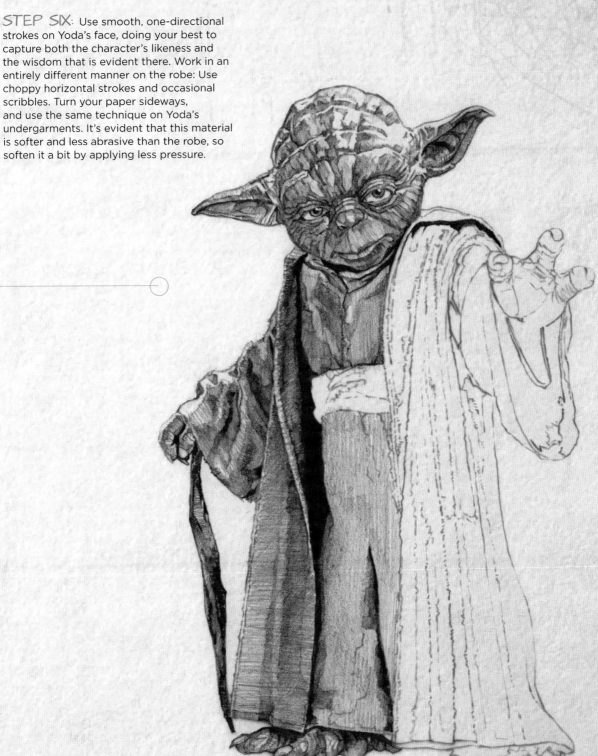

STEP SEVEN: Keep working on the undergarments and robe, moving from left to right. Don't worry about the pencil strokes moving past the edge of the robe. They'll erase easily later.

The choppy horizontal strokes and occasional scribbles on the robe will add some textural contrast to the drawing and also convey that Yoda's robe is made of some sort of rough, primitive material.

STEP EIGHT: Move back over the entire drawing with a 4H pencil, smoothing some areas and darkening others. Add a tiny drop of gesso to each of Yoda's eyes, giving them some sparkle and making them appear a little more expressive and lifelike. Gesso is a liquid, chalk-based medium used for prepping canvas. It's inexpensive, matte, and you can draw directly on top of it. After that, finished, this Yoda drawing is!

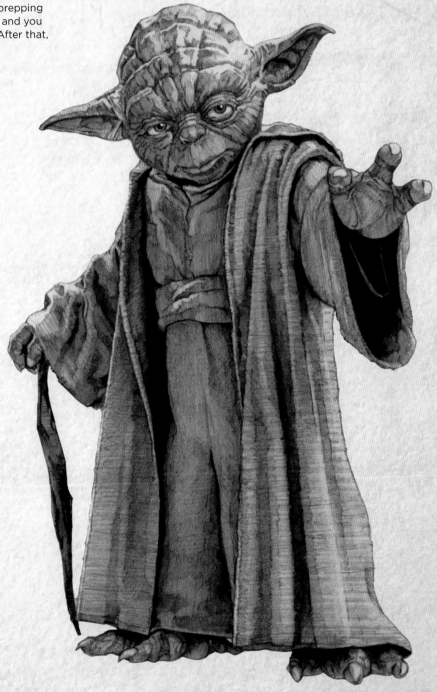

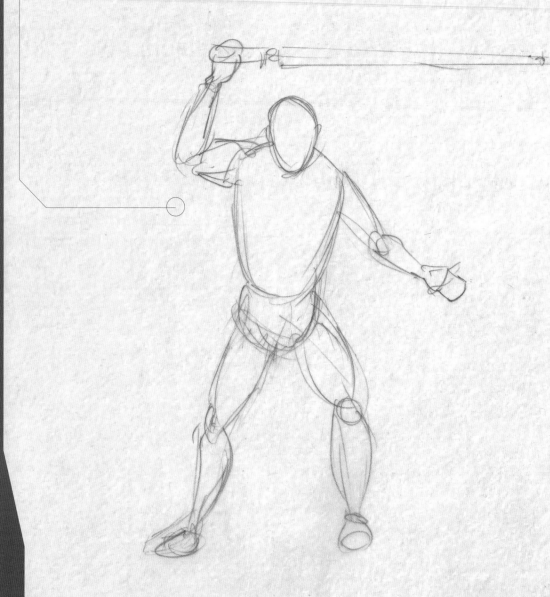

WINDU 1

STEP ONE: Mace Windu is not particularly tall, but he's broad, so indicate that in your initial sketch by slightly exaggerating the size of his chest.

A Jedi Master with an amethyst-bladed lightsaber, Mace Windu is a champion of the Jedi Order, with little tolerance for the failings of the Senate, the arguments of politicians, or the opinions of rebellious Jedi. Mace Windu is one of the finest fighters on the Jedi council, so he is depicted here in battle mode, his lightsaber ready for action.

STEP TWO: Rough out the gigantic robes and his undergarments. Locate the facial features, and verify their size and shape.

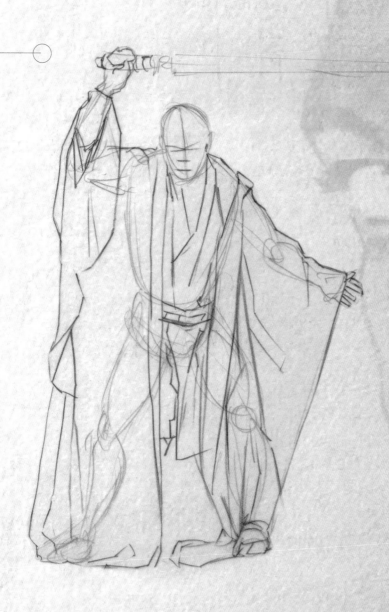

"I sense a plot to destroy the Jedi."

STEP THREE: Add more detail and clean up some of the underdrawing, but it's not necessary to entirely erase it.

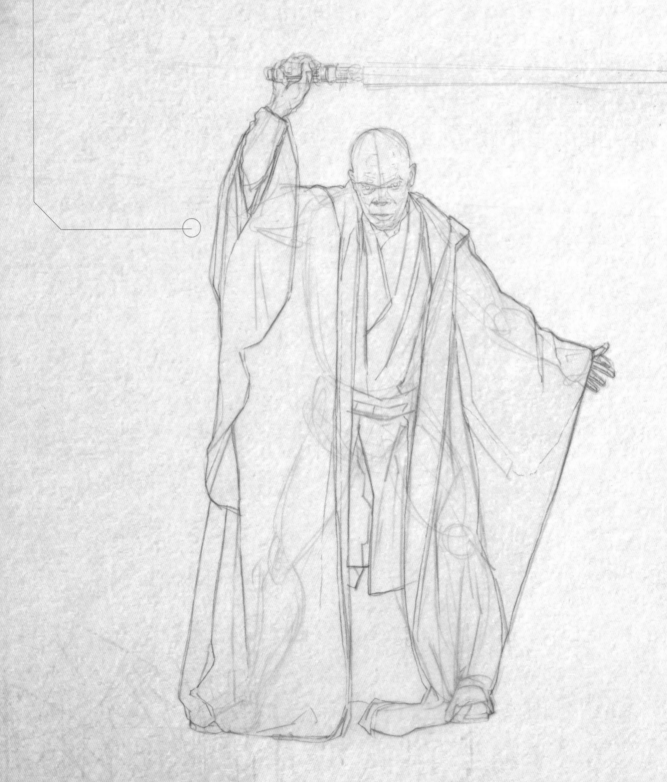

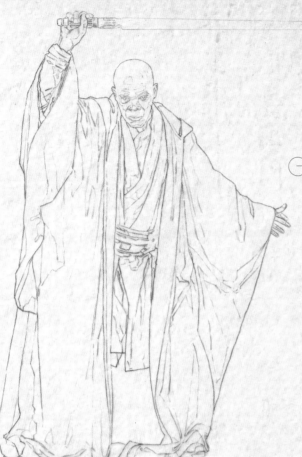

STEP FOUR: Complete your underdrawing. Outline all of the variations in value. You will blend these together as you move toward the final image.

ꓘꓴꓶꓷ 5

STEP FIVE: Lay down tone and value on Windu's robe, while establishing its texture with a loose pencil stroke at about a 45-degree angle. By angling the pencil work, the lines lead the viewer's eye to Windu's face, which is framed by his right arm and lightsaber.

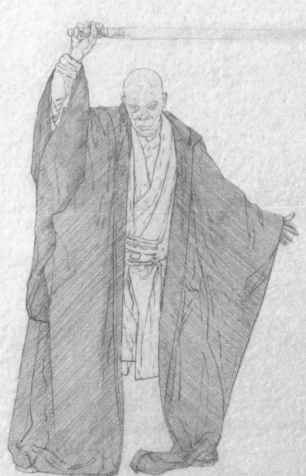

STEP SIX: Begin to add shadows and contrast, starting at the left and moving to the right. Then use a soft #2 pencil to establish the darkest area in the piece, the shadowy area just under his tabard, which fades toward gray at the bottom of the composition.

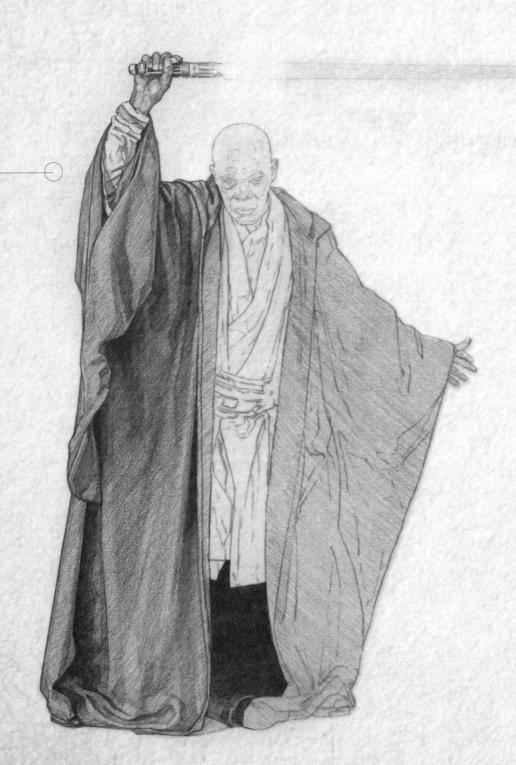

STEP SEVEN: Work on the lightsaber in this step. Carefully cut a piece of masking tape to shape, and lay it over the brightest part of the saber. Then, using short up-and-down pencil strokes with a dull #4H pencil, block in the shape. Remove the tape and lightly soften the edges. Dip an old toothbrush in gesso and lightly spatter the surface after covering the rest of the drawing with a sheet of paper, to protect it from the gesso. (See a different technique for drawing lightsabers on page 54.)

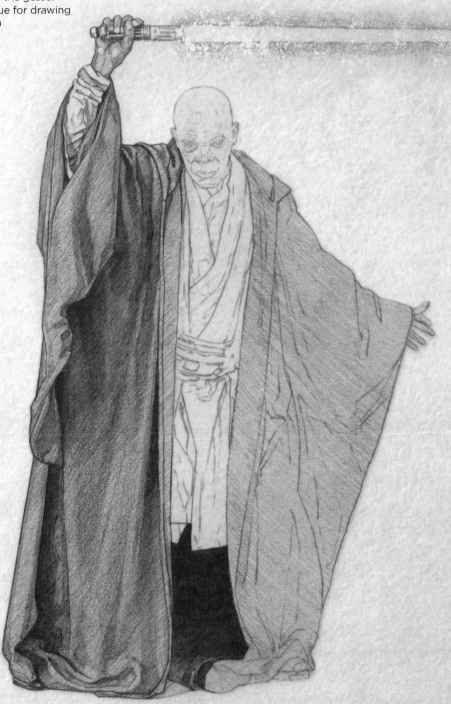

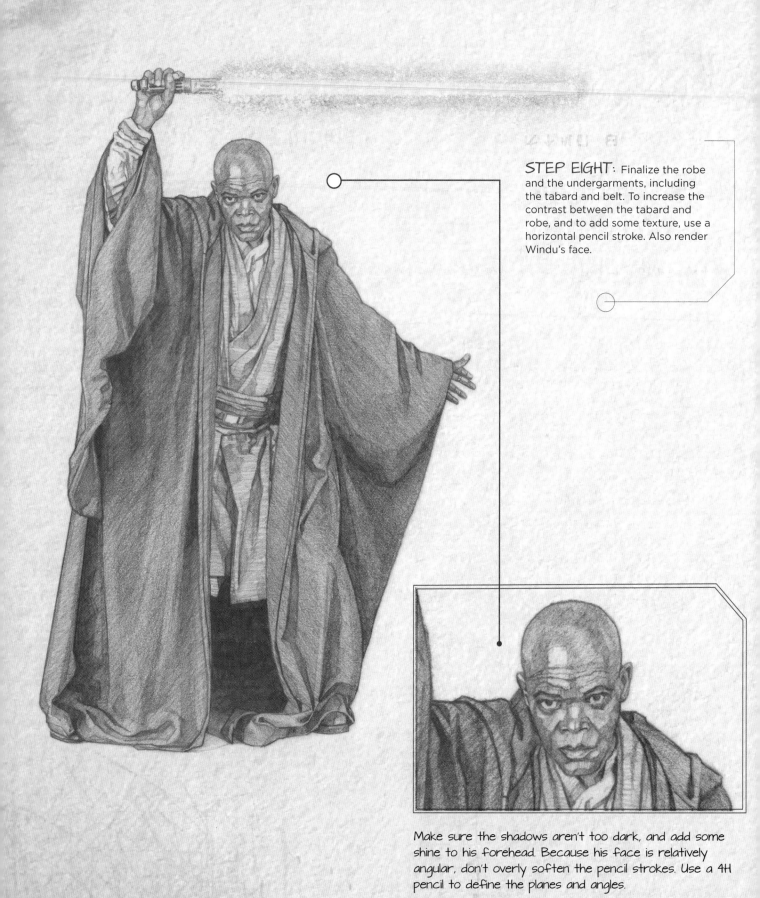

STEP EIGHT: Finalize the robe and the undergarments, including the tabard and belt. To increase the contrast between the tabard and robe, and to add some texture, use a horizontal pencil stroke. Also render Windu's face.

Make sure the shadows aren't too dark, and add some shine to his forehead. Because his face is relatively angular, don't overly soften the pencil strokes. Use a 4H pencil to define the planes and angles.

STEP NINE: Now it's just the final touches. Using a very small brush (a 20/0), add a drop of gesso "sparkle" to each eye. Additionally, add some contrast/value with a soft, dull #2 pencil, and blend some of the harsher pencil strokes in the robe and tunic. In your final drawing, Mace Windu's pose, large robes, and activated lightsaber should make him an imposing figure.

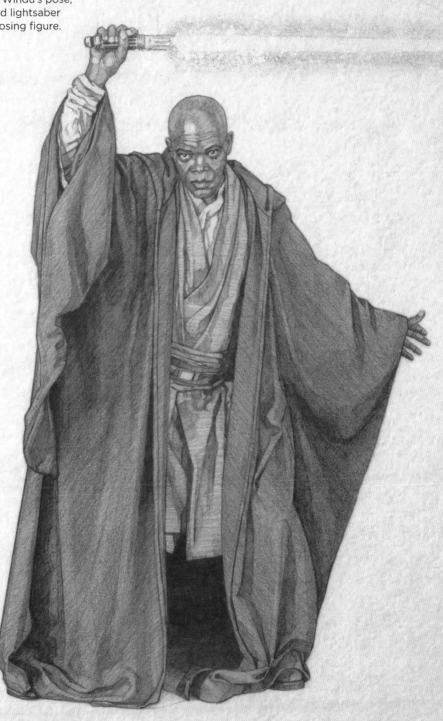

STEP ONE: As you begin to sketch, remember that Padmé's legs are relatively short and that she's long-waisted. Keep in mind that there is perspective at work here, particularly with regard to the giant blaster she's holding in her right hand. Her left arm is at her side, and only a small portion of it shows in the finished piece. Her feet, which are placed far apart, make the final drawing even more dynamic.

"My fate will be no different to that of our people."

STEP TWO: Add some definition throughout the entire sketch. Place her hair, face, arm, blaster, shirt, belt, and boots. When working on the arm, make sure the foreshortening is correct.

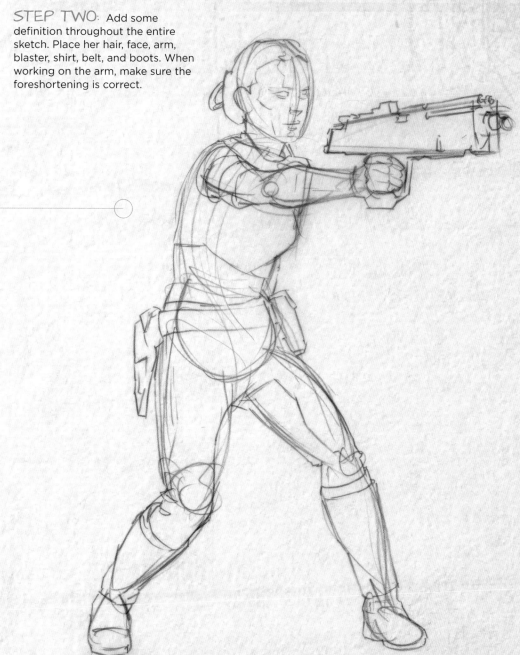

Padmé Amidala is a courageous, hopeful leader, serving as Queen, and then Senator, of Naboo and is also handy with a blaster. Despite her ideals and all she does for the cause of peace, her secret, forbidden marriage to Jedi Anakin Skywalker proves to have dire consequences for the galaxy.

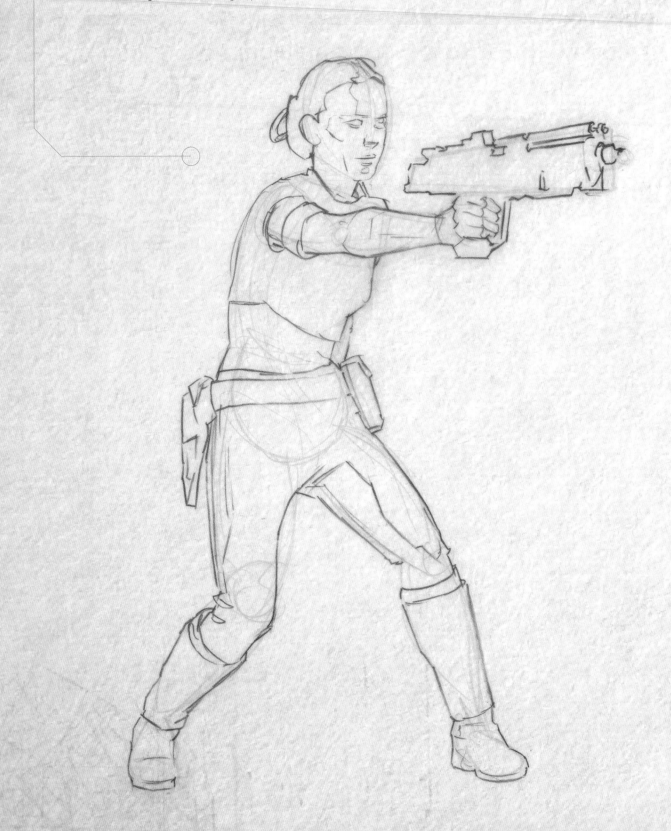

STEP FOUR: Using a magnifying lens, begin working on the face, using a light touch and a 4H pencil. Drawing almost everything you see in your reference makes it easier to shade and accurately depict the play of light. Also add some detail to her blaster and her boots.

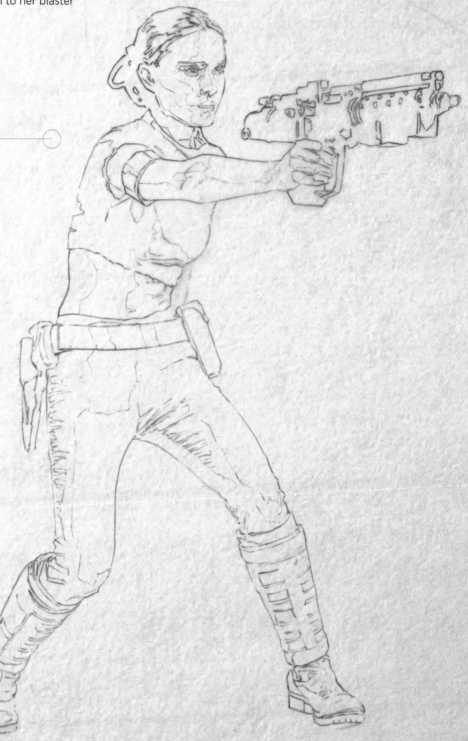

STEP FOUR (CONT.): Padmé's magnificent cheekbones are so essential to the character's look that they must be depicted correctly for a good likeness. Pay close attention and spend some time working on her face. To create the correct shapes when adding shadow, make sure you have everything you need on paper before you begin shading.

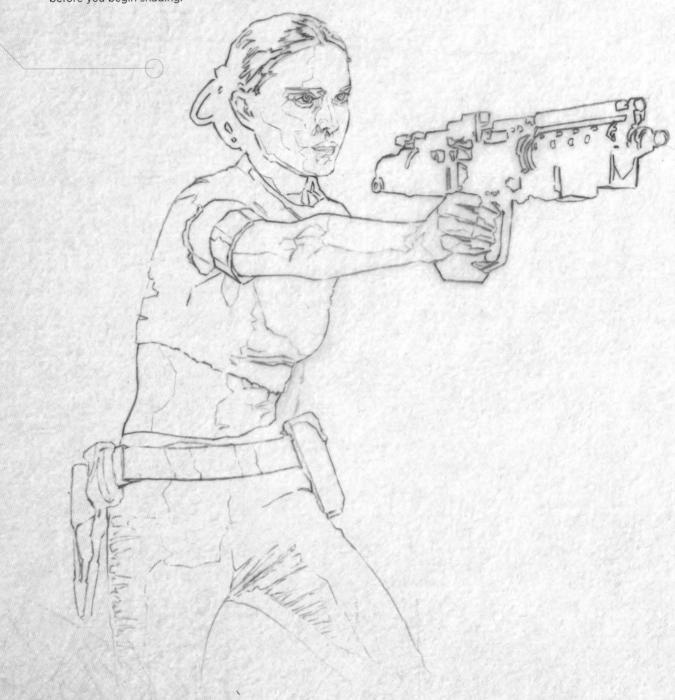

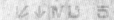

STEP FIVE: Add a little extra contrast under her brows, shadowing her eyes a bit. Vary your pencil stokes so that there's some contrast and tension between them. Even though the costume is white, there are still some fairly prominent areas of shadow. And although Padmé's skin is light, it is nowhere near as light as the color of her costume.

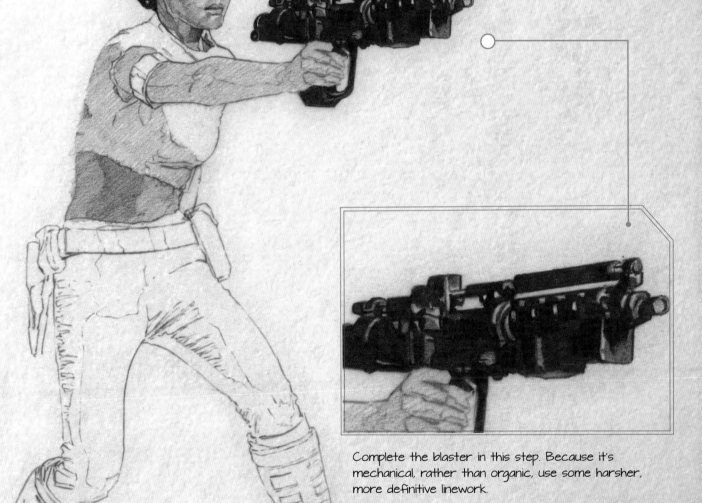

Complete the blaster in this step. Because it's mechanical, rather than organic, use some harsher, more definitive linework.

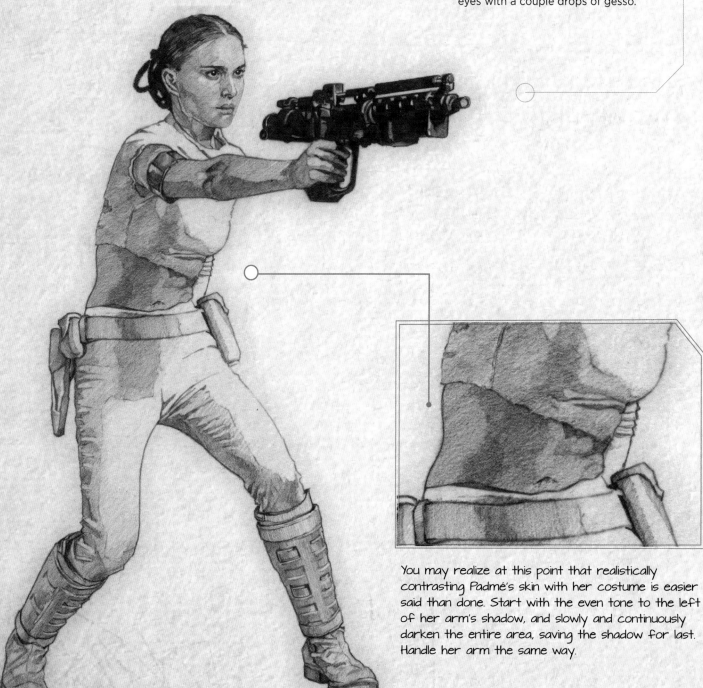

STEP SIX: Finish shading the bottom half of Padmé. Check that her likeness is where you want it to be. Make sure her eyes are not flat and one-dimensional, and that her mouth is not too narrow. One of Padmé's most prominent features are her full lips. Also add a little sparkle to the eyes with a couple drops of gesso.

You may realize at this point that realistically contrasting Padmé's skin with her costume is easier said than done. Start with the even tone to the left of her arm's shadow, and slowly and continuously darken the entire area, saving the shadow for last. Handle her arm the same way.

STEP SEVEN: Smooth things out, softening some areas, and adding a little more contrast and texture in others. Bounce throughout the image, fixing or adjusting little things here and there. Soften and darken the stomach a bit, and add a little dirt to the bottom of the boots. In your finished piece, Padmé's expression and body posture should convey the intense emotions she's feeling.

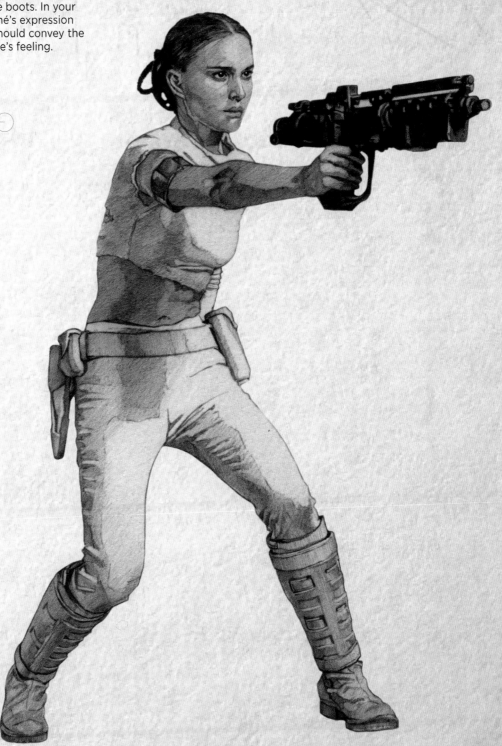

STEP ONE: In this drawing, C-3PO is depicted from the waist up and popping out of a dark background frame. His arms bend in a way that seems awkward for a human but completely natural for a droid. Start with angles and sharp-edged shapes, keeping in mind that his body is basically a collection of chrome-like cylinders.

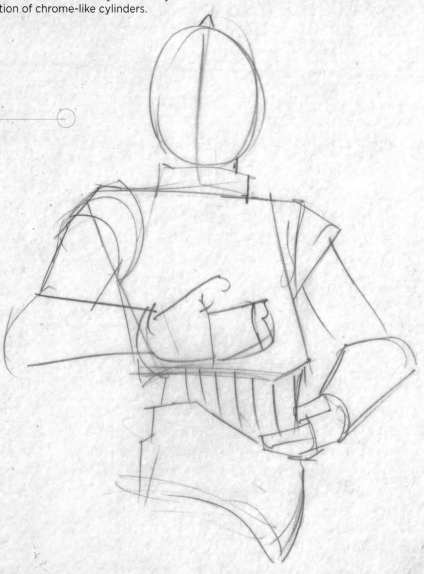

Built by Anakin Skywalker, C-3PO is programmed for etiquette, protocol, and fluency in more than 6 million forms of communication. Companion to astromech R2-D2, Threepio is involved in some of the galaxy's most defining moments and thrilling battles. Particularly after spending a lot of time dealing with fabric and skin, you should enjoy drawing the reflections and shine on C-3PO.

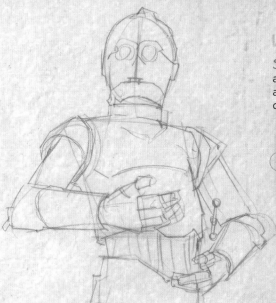

ᴎↆⅤⅠ ⅱ

STEP TWO: Refine shapes and add details. Locate Threepio's eyes and audio emitter, and begin the process of defining his complicated hands.

ᴎↆⅤⅠ ⅱ

STEP THREE: Define the silhouette and erase sketch lines. Place lines along the outside frame.

"I am C-3PO, human-cyborg relations."

STEP FOUR: Keep adding details to the entire drawing, defining the shapes by line, rather than shade. Do this correctly, and the shading will be relatively easy.

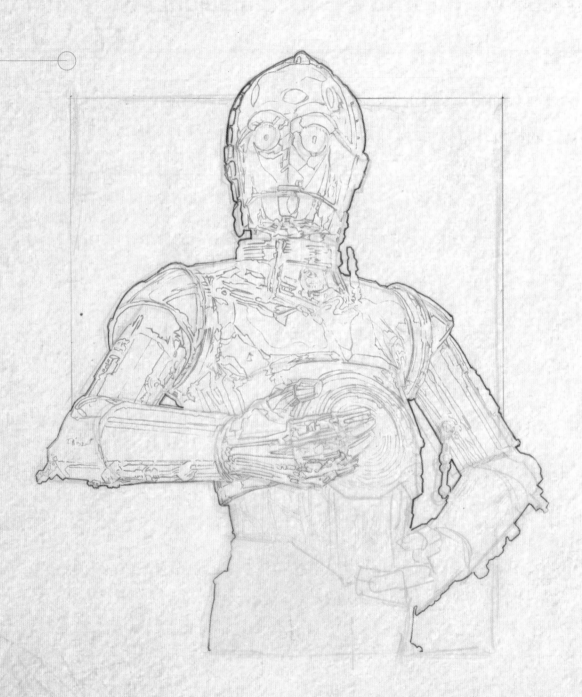

STEP FIVE: Finish the interior linework. Remember that the linework is a guideline. As you shade, you'll make some changes, and that's OK.

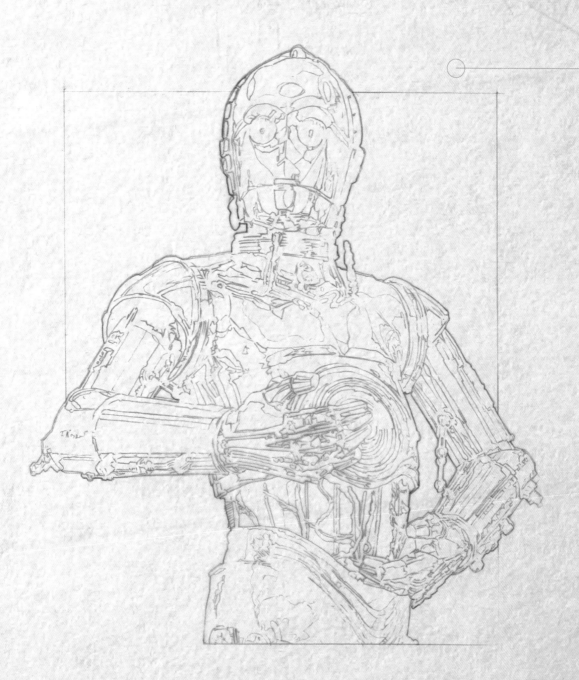

STEP SIX: Begin shading C-3PO's head. It has a wide variety of values ranging from black to white, so it establishes a baseline for shading the rest of the drawing.

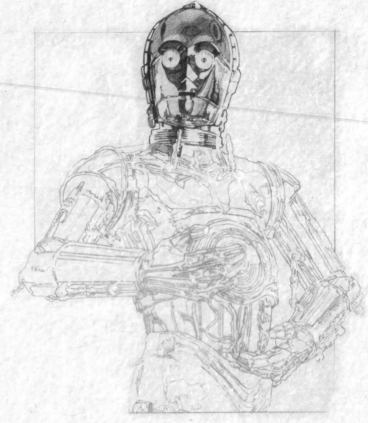

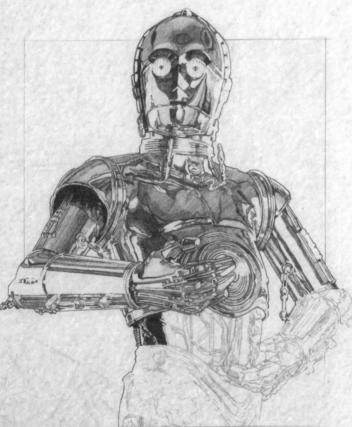

STEP SEVEN: C-3PO is complicated and will take a long time. Continue shading, working from the upper left to lower right. Nothing ruins the look of a shiny metallic surface more than smeared graphite, so be careful! Place a sheet of clean paper over your drawing and rest your hand on that.

STEP EIGHT: Finish shading the rest of the torso and hips. The black, ribbed area around C-3PO's torso would be easier if you simply shade it and leave the ribbing off. In a sketch, that's OK, but in a finished, fine-art style piece, draw the entire thing in detail.

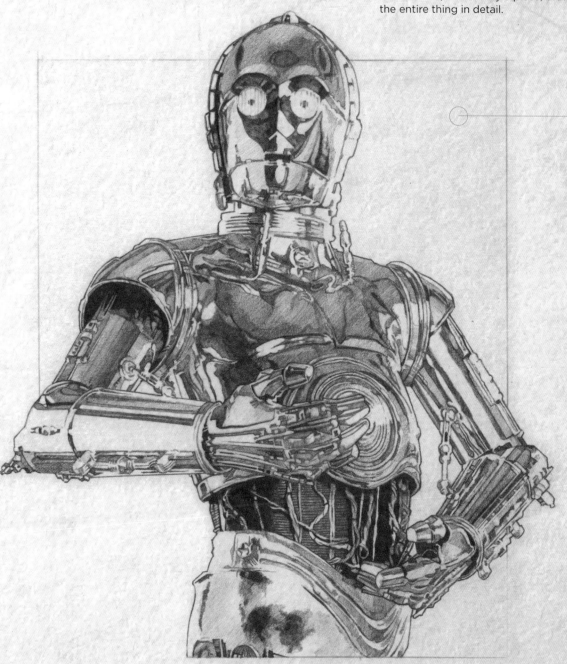

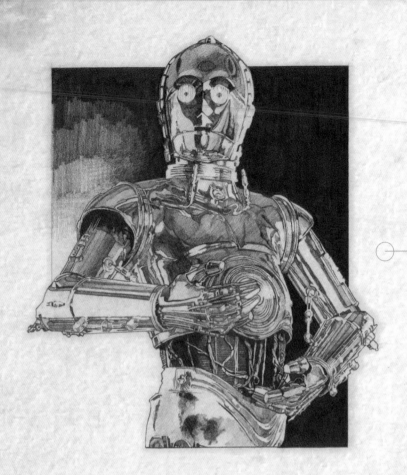

STEP NINE: Work on the background frame. To achieve a rich, deep, velvety black, use a soft #2 pencil and keep the strokes moving in the same direction.

ᛉᛏᛝ ᛁᛒ

STEP TEN: Blend the background strokes together a little and blot out some areas with a kneadable eraser. There's no right or wrong way to do this. Shoot for a smoky, organic texture to act as a counterpoint to the mechanical look of C-3PO.

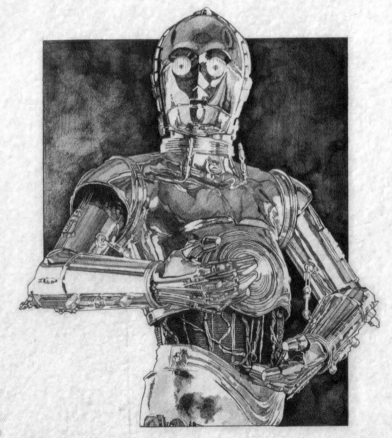

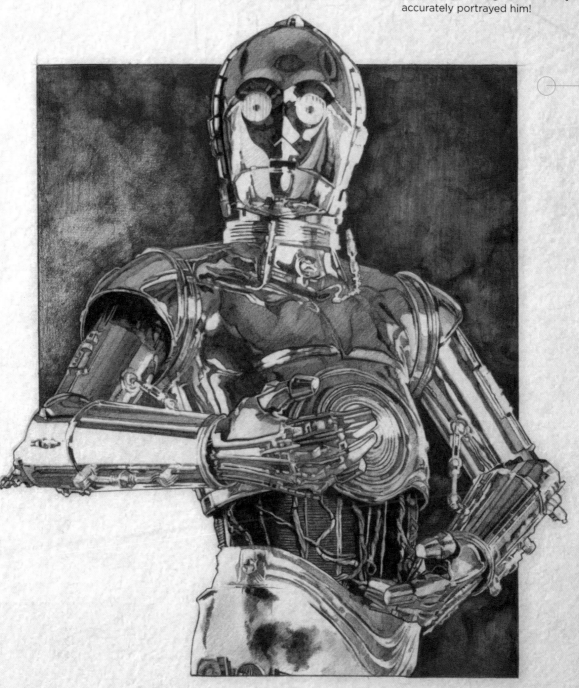

STEP ELEVEN: The drawing is now ready for the final polish. Smooth out some textures on Threepio's body and diminish the contrast in areas where it is too strong. Once finished, this protocol droid should look like he's calculating the degree to which you accurately portrayed him!

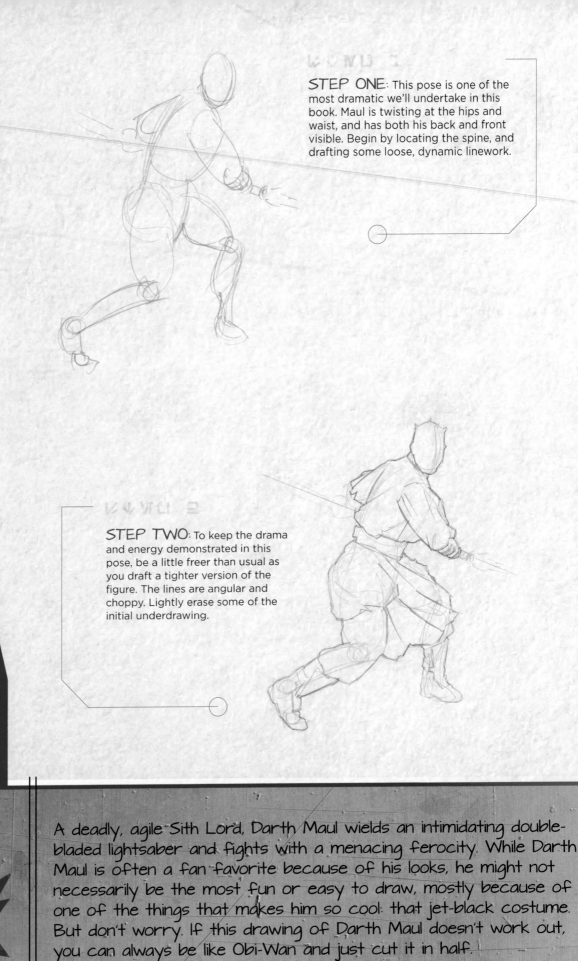

STEP ONE: This pose is one of the most dramatic we'll undertake in this book. Maul is twisting at the hips and waist, and has both his back and front visible. Begin by locating the spine, and drafting some loose, dynamic linework.

STEP TWO: To keep the drama and energy demonstrated in this pose, be a little freer than usual as you draft a tighter version of the figure. The lines are angular and choppy. Lightly erase some of the initial underdrawing.

A deadly, agile Sith Lord, Darth Maul wields an intimidating double-bladed lightsaber and fights with a menacing ferocity. While Darth Maul is often a fan favorite because of his looks, he might not necessarily be the most fun or easy to draw, mostly because of one of the things that makes him so cool: that jet-black costume. But don't worry. If this drawing of Darth Maul doesn't work out, you can always be like Obi-Wan and just cut it in half.

STEP THREE: In this step, begin drafting some of the internal linework. A lot of this is guesswork. It's OK to make a mistake here. Because Maul's costume is such a dark matte black (and like the dark side of the Force, it basically absorbs light), many of the folds and wrinkles won't be visible except on extremely close inspection.

"At last we will have revenge."

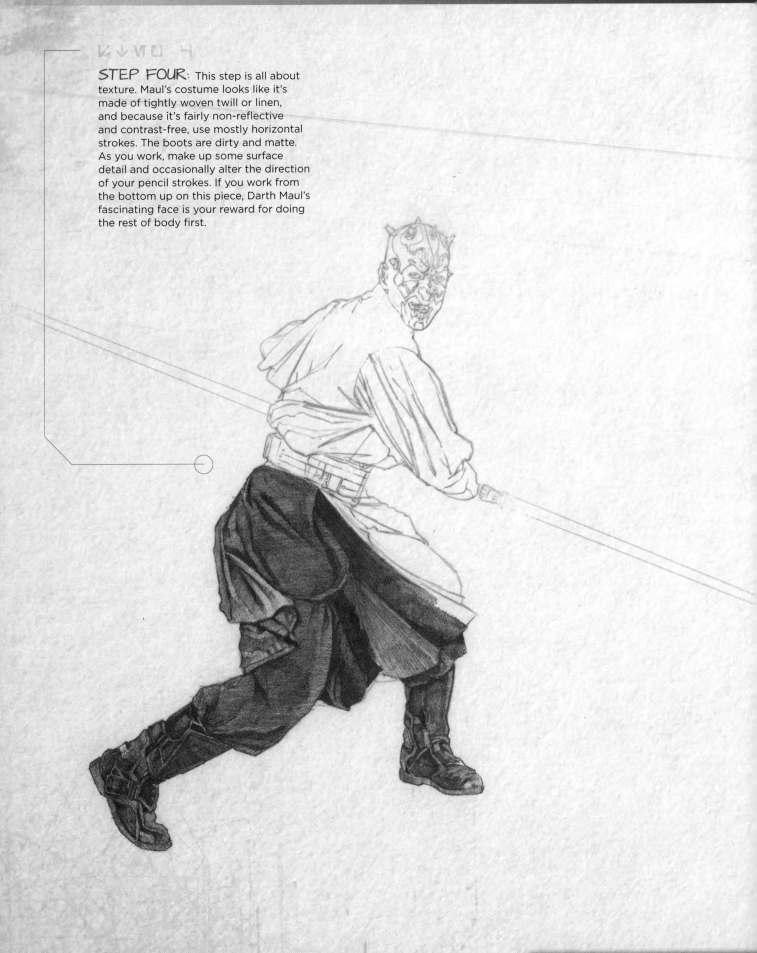

STEP FOUR: This step is all about texture. Maul's costume looks like it's made of tightly woven twill or linen, and because it's fairly non-reflective and contrast-free, use mostly horizontal strokes. The boots are dirty and matte. As you work, make up some surface detail and occasionally alter the direction of your pencil strokes. If you work from the bottom up on this piece, Darth Maul's fascinating face is your reward for doing the rest of body first.

STEP FIVE: Because a realistic depiction of light is what gives a drawing the illusion of three dimensions, it's difficult to build a sense of realism when the subject is very dark. Force the contrast on the dark costume and only use a deep black in heavily shadowed areas. Define the belt and emphasize the fact that it is a completely different material from the rest of the costume.

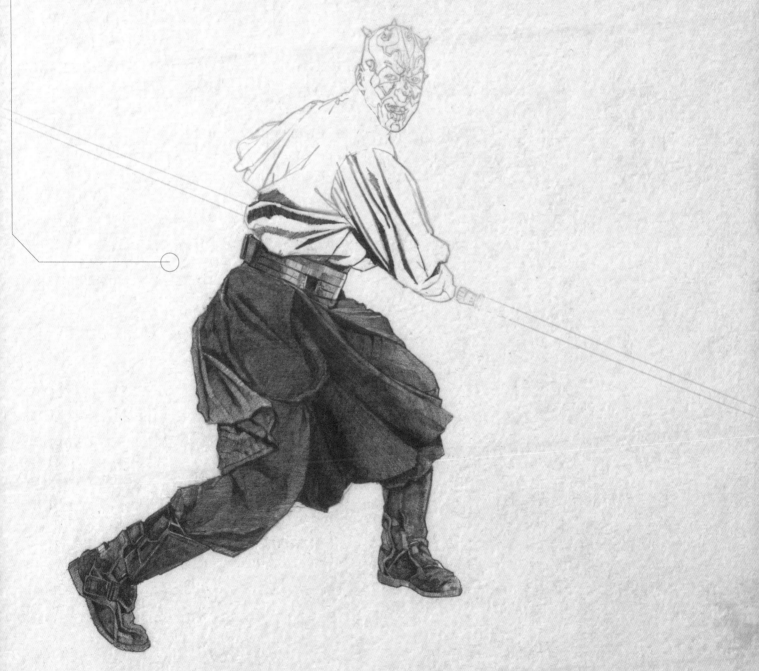

STEP SIX: Add horizontal strokes
on his shirt, and you will already be able
to see the shadows blending into the
material.

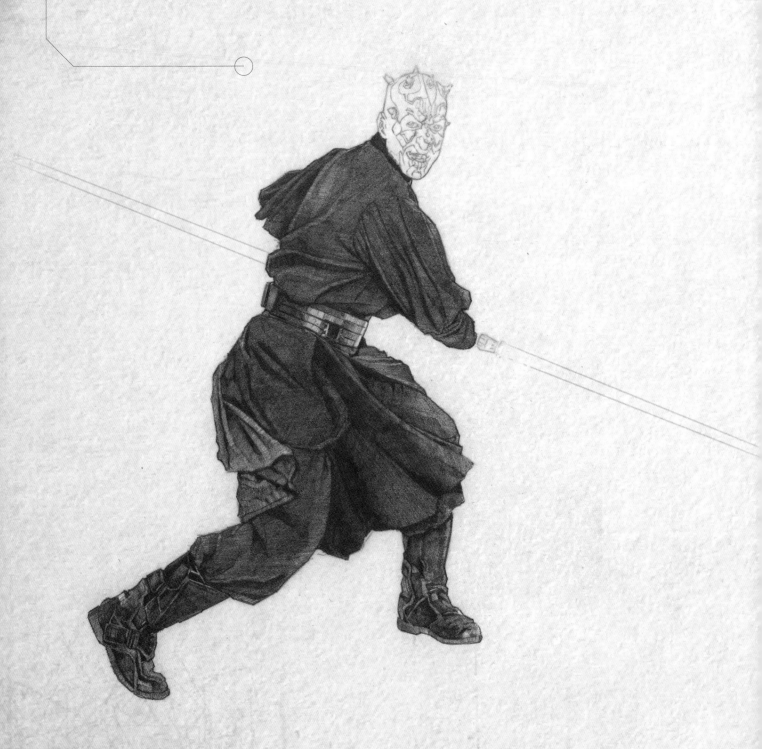

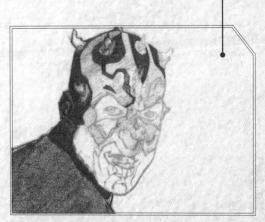

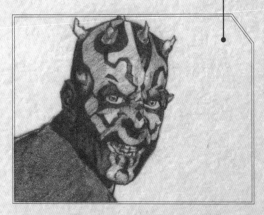

Darth Maul's head is covered with black tattoos, so pay close attention to your reference and note their placement. He also has horns bursting out of his skin, multi-colored irises, and dirty teeth, which he is baring here.

After you add value to the rest of Darth Maul's snarling face, his head is almost complete. During the final polish, go back and add tiny drops of gesso for eye shine.

STEP EIGHT: Now add Darth Maul's double-bladed lightsaber. There are a couple of different ways to render these weapons (see page 29 for another technique). For this technique, use choppy, loosely blended pencil strokes against a white core.

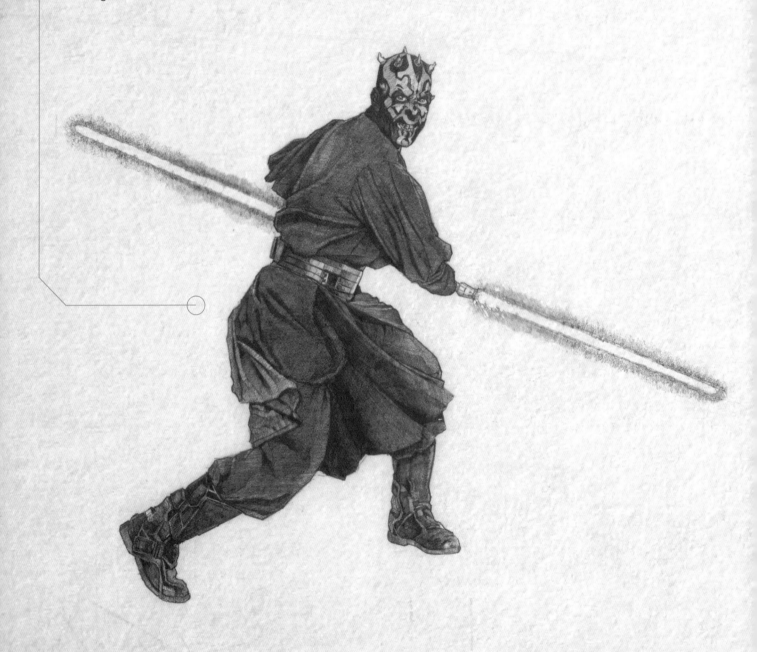

STEP NINE: The final polish for this piece includes a general smoothing; soften and darken the costume. Also add a gleam to Maul's eyes with gesso, and splash a little bit of gesso (by dipping a toothbrush and running your finger along the bristles) around the lightsaber's ignition point. Now that you are finally done, the shine in his eye, snarling face, and in-motion pose should convey Darth Maul's eagerness to exact revenge and destroy the Jedi.

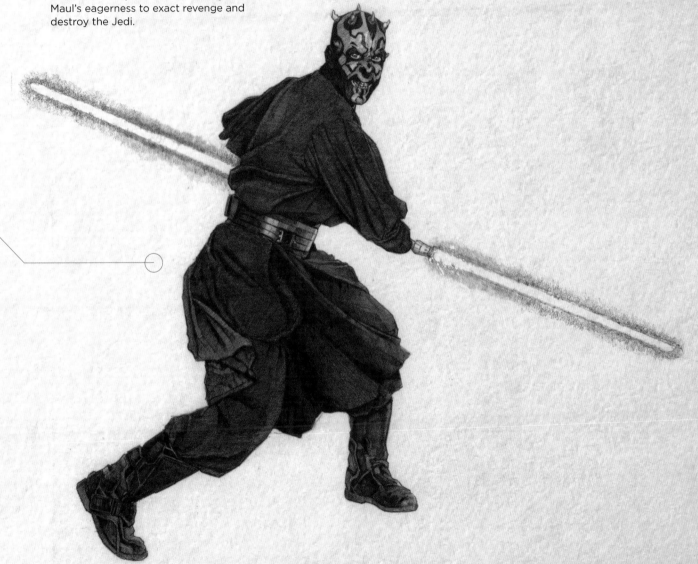

STEP ONE: Think about intensity as you begin your initial sketch, and start with an aggressive pose: Anakin has his legs apart, chest out, and head down.

"I do not fear the dark side as you do."

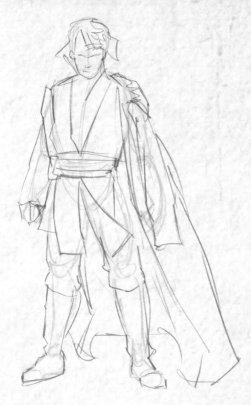

STEP TWO: Locate where the hair, facial features, and clothes will go, paying attention to the movement captured in the folds of his clothing. It should appear as though Anakin is standing in a steady wind.

STEP THREE: Tighten up your linework. Rough out the hair and finalize the silhouette.

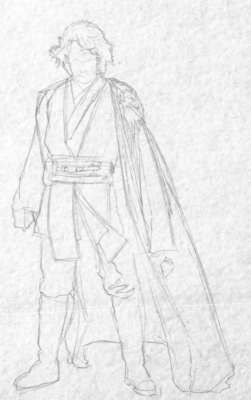

As a young man, Anakin Skywalker has the potential to become one of the most powerful Jedi ever and is believed by some to be the prophesied Chosen One who would bring balance to the Force. Anakin Skywalker does fulfill his destiny many years after becoming Darth Vader, destroying the Emperor and saving the galaxy. Our goal is to depict his shadowy intensity as we attempt to portray the anguished Anakin.

STEP FOUR: Now concentrate on the variations in light and shadow, rather than on the actual outlines. Pay special attention to the face. Because Anakin is so dramatically lit here, there's not as much subtlety, and this makes him a little easier to draw. However, you still need to make sure you capture his expression—a mixture of sorrow and anger—correctly.

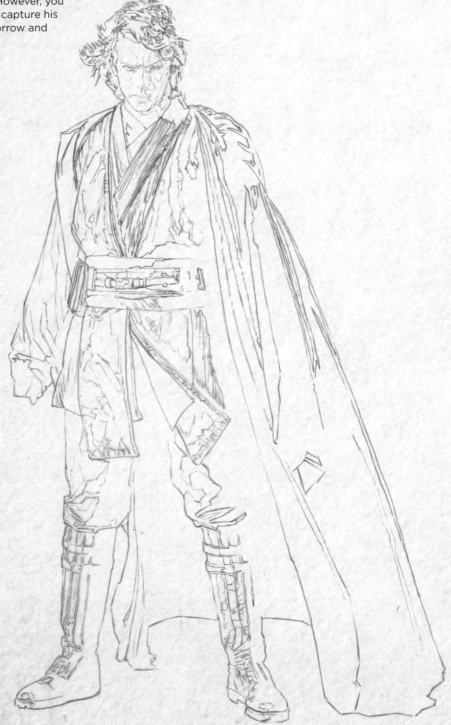

STEP FIVE: Begin shading Anakin's robes, moving from left to right. Then work on the face and hair. To get a good likeness, be extremely careful as you depict the face. When you move into the hair, you can be a little more free. Just remember where the light source is and that hair is reflective. Anakin's hair is tangled and blowing in the wind, so there will be some guesswork with regard to light and shadow.

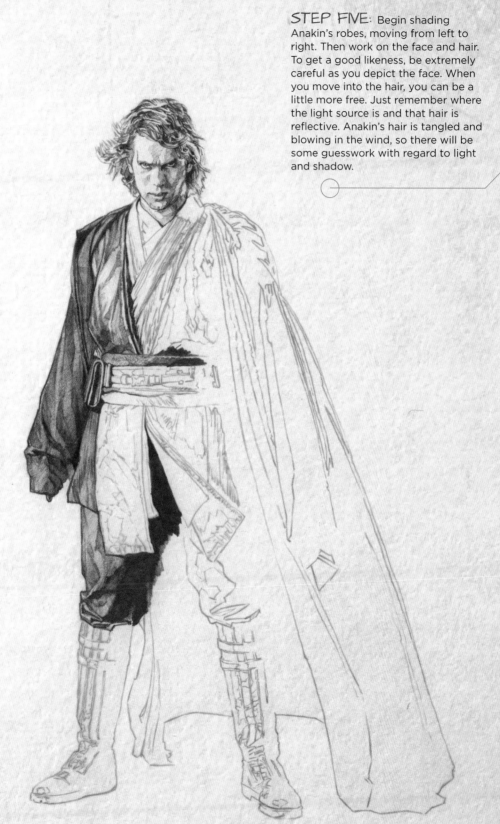

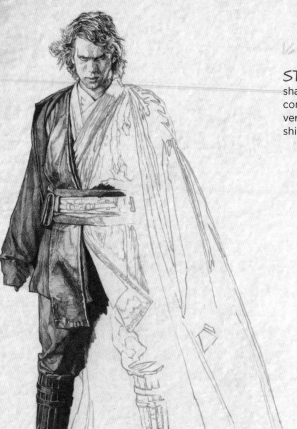

STEP SIX: As you continue to shade Anakin's clothing, think about the contrasting textures—the ribbed tunic versus the rough-hewn robe versus the shiny leather tabard and boots.

ᴋ ↓ ⴸⵕ 7

STEP SEVEN: By the time you reach this step, you will have worked with each of the different textures visible in the image. Use horizontal strokes on the robe and vertical strokes on his tunic, which should sort of duplicate the ribbing. For the boots and tabard, it's less about texture and more about contrast. It's essential that both the shine and shadow be evident in the finished work.

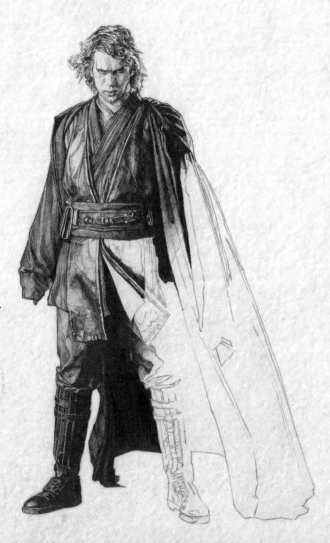

STEP EIGHT: It's important that the blacks in a finished portrait be as deep and dark as possible. To do this, use a soft #2 pencil and push hard, doing your best to keep all of your pencil strokes going in the same direction. You could achieve a darker black with charcoal, but it would be obvious in the finished piece that you used two different types of media.

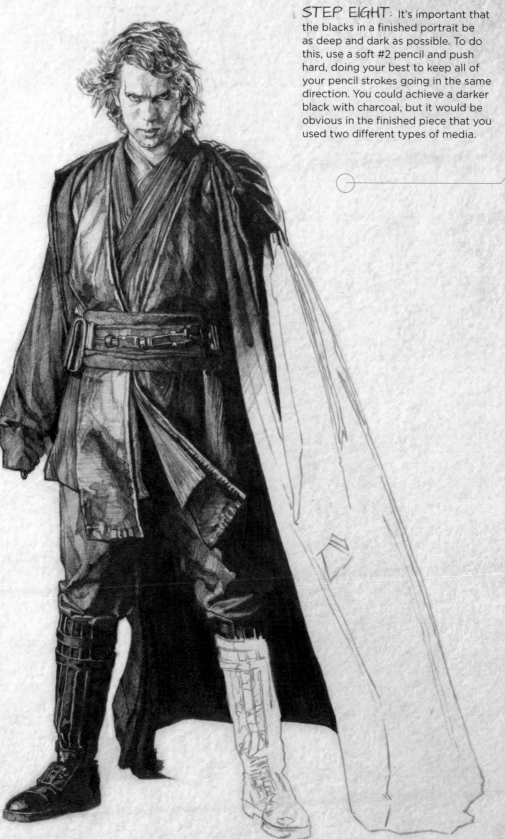

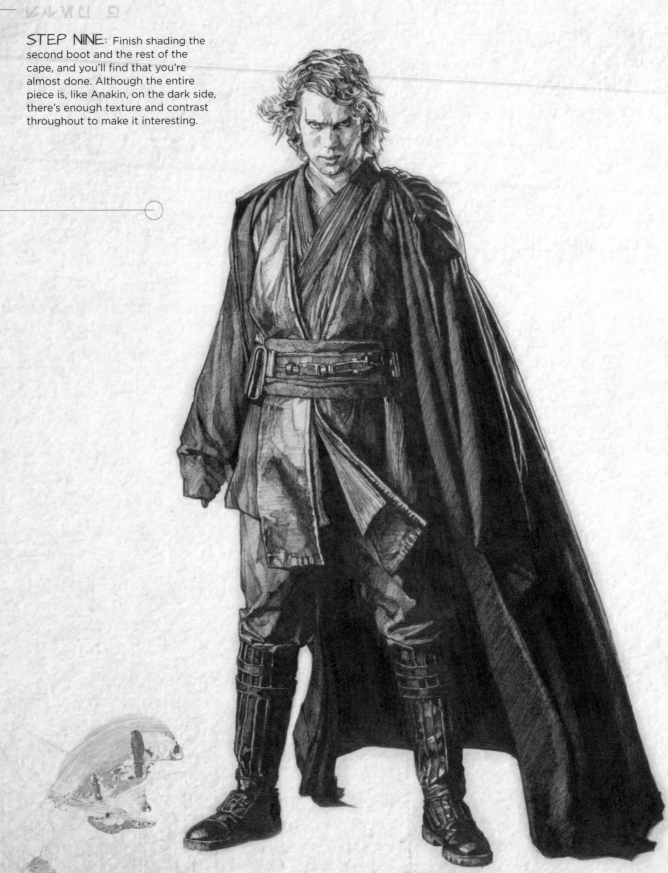

STEP NINE: Finish shading the second boot and the rest of the cape, and you'll find that you're almost done. Although the entire piece is, like Anakin, on the dark side, there's enough texture and contrast throughout to make it interesting.

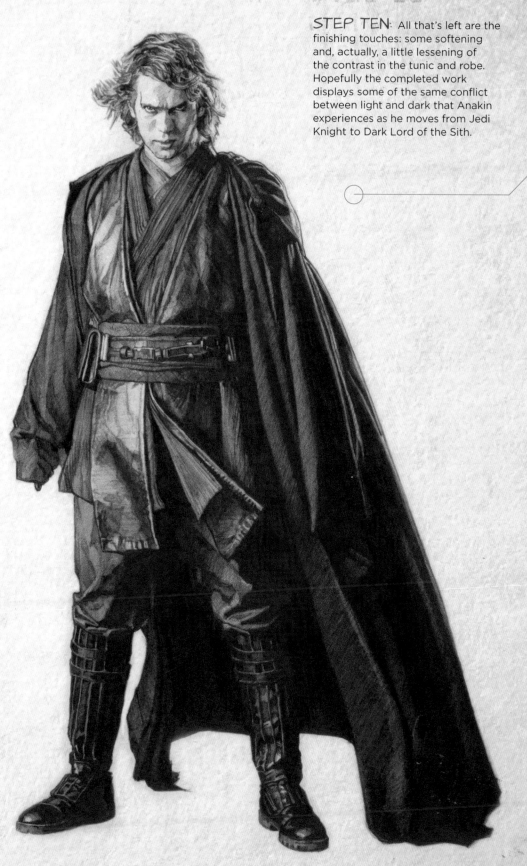

STEP TEN: All that's left are the finishing touches: some softening and, actually, a little lessening of the contrast in the tunic and robe. Hopefully the completed work displays some of the same conflict between light and dark that Anakin experiences as he moves from Jedi Knight to Dark Lord of the Sith.

STEP ONE: Rough out Darth Vader's general shape. His stance is one of confidence and power, with his feet apart and hands on his hips. Keep in mind that everything about him—his head, forearms, feet, etc.—is bigger than average.

"If you only knew the power of the dark side."

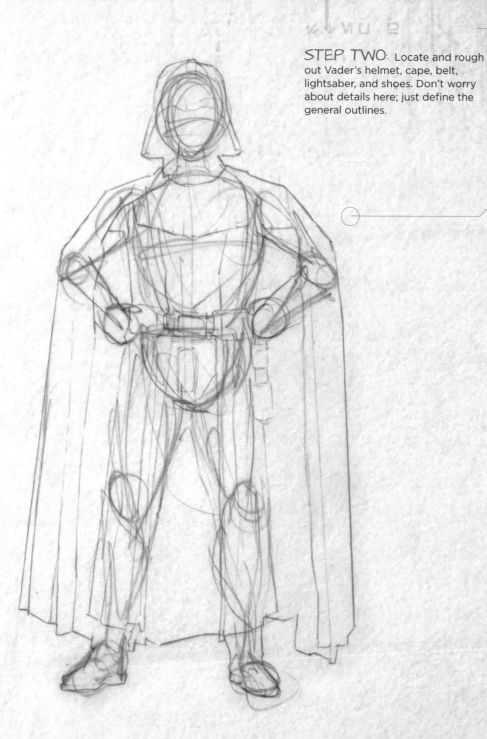

STEP TWO: Locate and rough out Vader's helmet, cape, belt, lightsaber, and shoes. Don't worry about details here; just define the general outlines.

Once a heroic Jedi Knight, Darth Vader is seduced by the dark side of the Force, and becomes a Sith Lord determined to crush the Rebel Alliance. Obi-Wan Kenobi describes Darth Vader as "more machine now than man, twisted and evil." When drawing the Dark Lord, use Obi-Wan's words as your guide. Machines are often angular and sharp, so use straight lines and hard edges, particularly in your initial sketches.

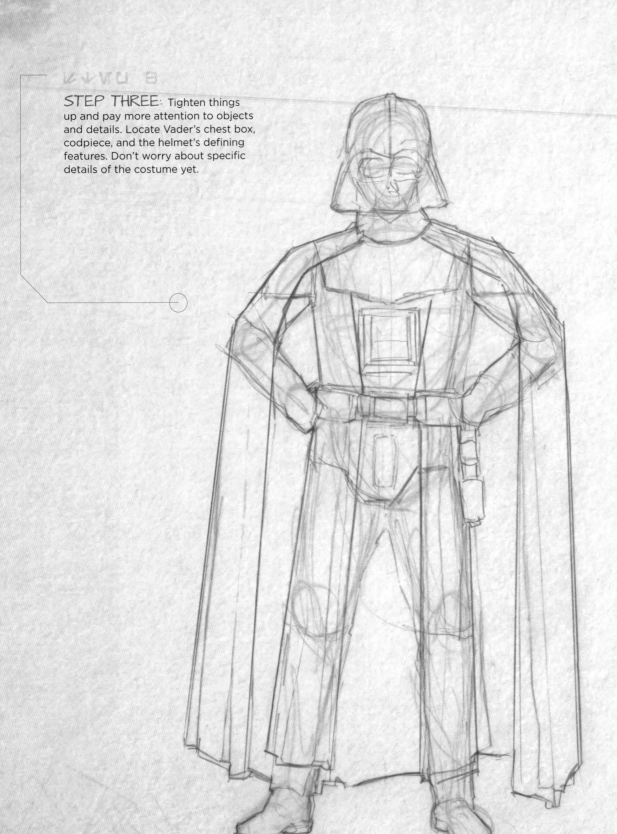

STEP THREE: Tighten things up and pay more attention to objects and details. Locate Vader's chest box, codpiece, and the helmet's defining features. Don't worry about specific details of the costume yet.

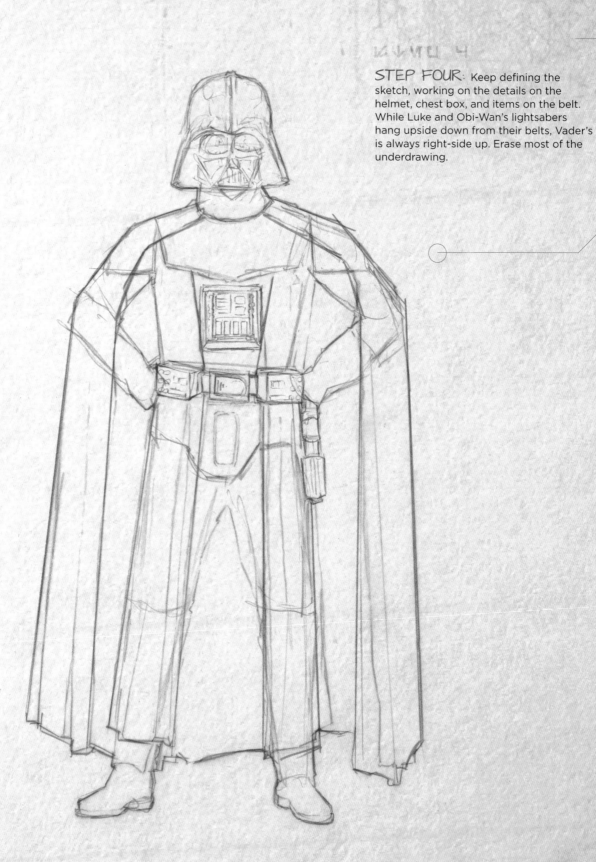

STEP FOUR: Keep defining the sketch, working on the details on the helmet, chest box, and items on the belt. While Luke and Obi-Wan's lightsabers hang upside down from their belts, Vader's is always right-side up. Erase most of the underdrawing.

STEP FIVE: Continue to tighten
the drawing, erasing any extraneous
lines and lightly drawing new lines. At
this stage, use four different values
(white, black, light and dark gray) to
outline shapes, knowing that
you will be filling them later.

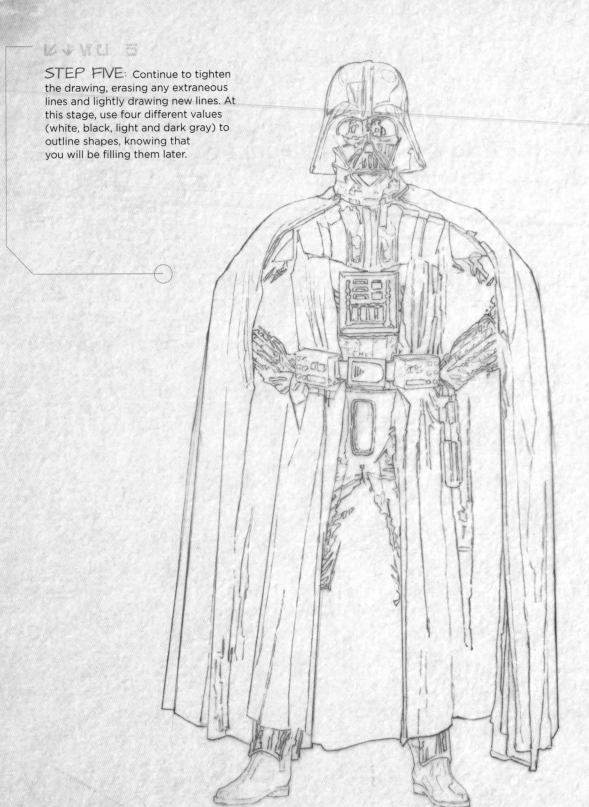

STEP SIX: Pay attention to all those little shapes you worked so hard to draw, and fill them in with the right value, blending as you go. Keeping the direction of your pencil strokes consistent, work from left to right and from top to bottom. Instead of limiting yourself to just the four values you used on the underdrawing, use the entire range of values while shading.

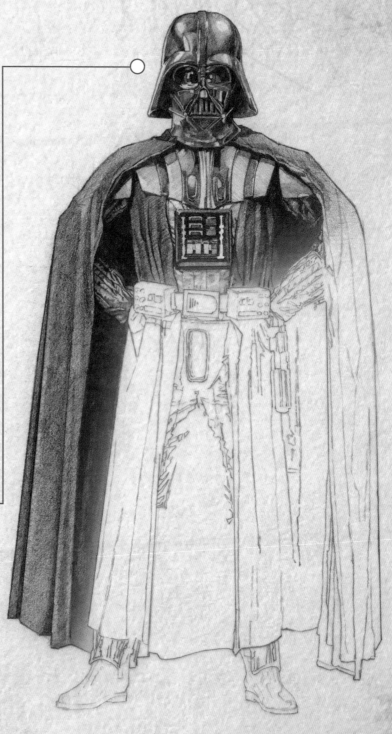

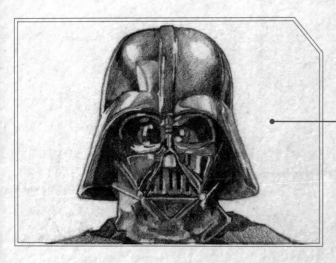

Not only is the helmet structurally different from side to side, it's painted that way, as well. The right cheek is black, and the left is gray. That pattern is reversed directly below his eyes. Keeping this asymmetry in mind as you draw will give your finished art an accuracy and authenticity that isn't often seen.

STEP SEVEN: Finish shading Darth Vader from the top left to the bottom right. You can go back and tighten everything up after shading.

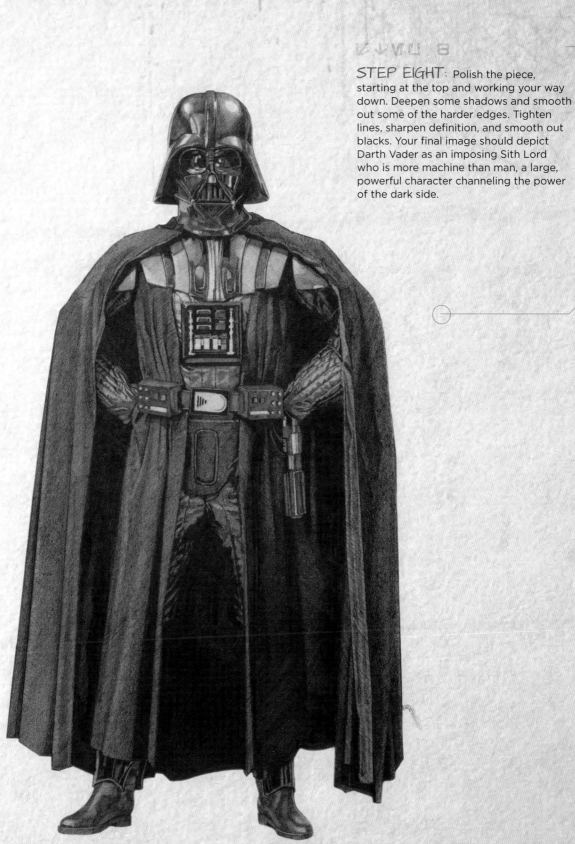

STEP EIGHT: Polish the piece, starting at the top and working your way down. Deepen some shadows and smooth out some of the harder edges. Tighten lines, sharpen definition, and smooth out blacks. Your final image should depict Darth Vader as an imposing Sith Lord who is more machine than man, a large, powerful character channeling the power of the dark side.

STEP ONE: This stormtrooper is running to the front line, weapon at the ready, to take the place of one of his fallen comrades. Since the trooper is running toward the viewer, some foreshortening is required on his left leg.

"Let me see your identification."

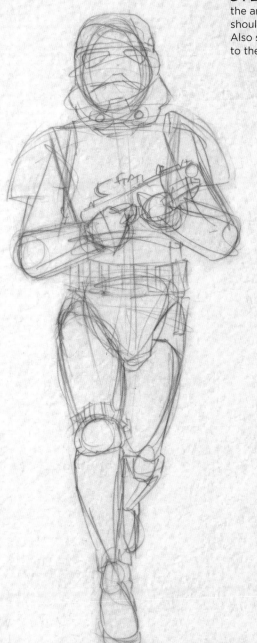

STEP TWO: Loosely outline the armor, including the helmet, big shoulder pads, chest plate, belt, etc. Also sketch the gun pointing up and to the right.

STORMTROOPER

Stormtroopers are shock troops fanatically loyal to the Empire. They wear imposing white armor, wield blaster rifles and pistols, and attack in hordes to overwhelm their enemies. Sure, their aim is bad, and with the way their armor rattles, it's difficult to sneak up on unsuspecting rebels. Nevertheless, the Emperor's endless supply of stormtroopers do wear really cool-looking uniforms.

STEP THREE: Complete more linework. Rough out the helmet and commit to some of the exterior lines that make up the stormtrooper's shape. Note that the right and left knees are different. The right has a gear-like shape, while the left has a flat front.

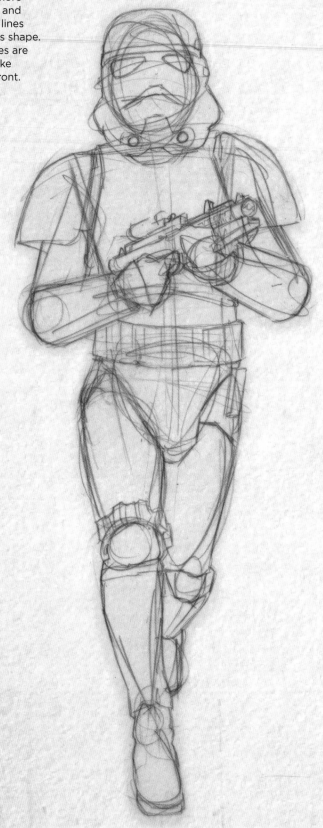

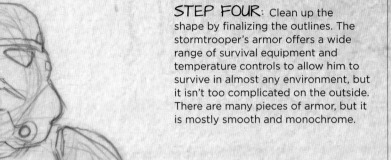

STEP FOUR: Clean up the shape by finalizing the outlines. The stormtrooper's armor offers a wide range of survival equipment and temperature controls to allow him to survive in almost any environment, but it isn't too complicated on the outside. There are many pieces of armor, but it is mostly smooth and monochrome.

STEP FIVE: Erase the underdrawing and add some small details on the armor, like the grooves on the arms, the gear-like shape on his right knee, the folds in the cloth on the boots, etc. Prepare for shading by adding some of the interior details. Do this by outlining the areas of different value that you see in your reference.

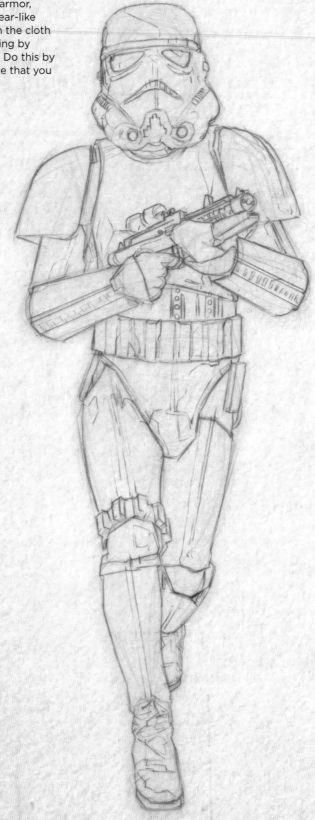

STEP SIX: Begin shading. Remember that even though we think of the armor as white, it's not *really* white in our drawing, except in areas where the light is hitting it directly. The armor in your finished drawing should still appear white, even with the variations in shade and tone that you've depicted.

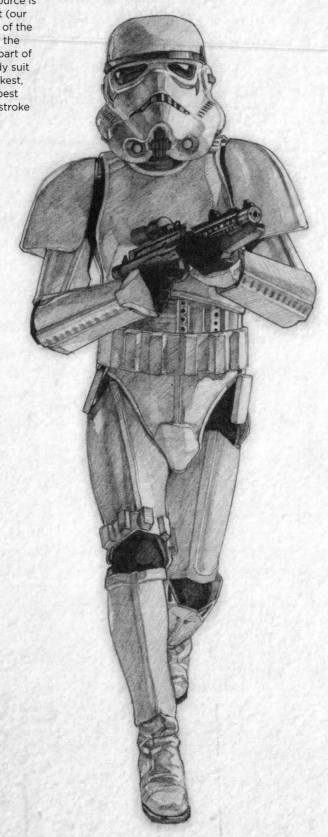

STEP SEVEN: The light source is in front and to the trooper's left (our right). This means that the side of the helmet on our right is receiving the most light and is the brightest part of the composition. The black body suit under the armor will be the darkest, most shadowed area. Do your best to use a one-directional pencil stroke throughout the entire piece.

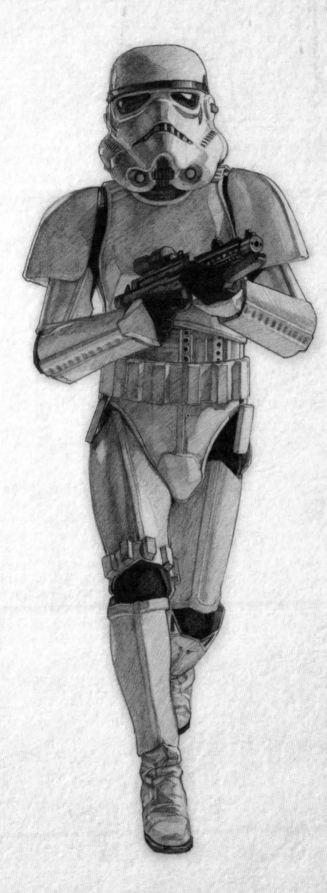

STEP EIGHT: At this point, the overall tone may still need a little work. To make the armor look more smooth and polished, use a dull 4H pencil and move around the drawing, blending, softening, and adding an overall shadowy gray in the areas where the armor is in shadow. Once you finish, you will have just added one more stormtrooper to the Imperial Army—but don't worry because we all know he'll only last about five minutes before he's blown up, or shot, or hits his head on a door frame.

STEP ONE: It's important to come up with a good approximation of Leia's form in this initial sketch. Be sure that the shape is feminine; in a *Star Wars* universe so crowded with masculine characters, sometimes that's easy to forget. Also rough out the blaster she is holding in her right hand.

"I hope you know what you're doing."

STEP TWO: Rough out Leia's robe. As you place the hood, turn her head toward the viewer a bit more.

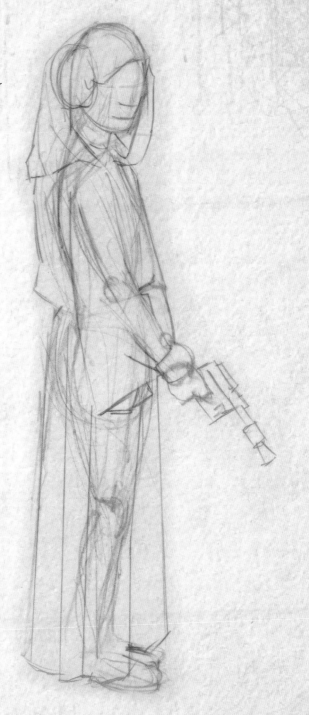

Princess Leia is one of the Rebel Alliance's greatest leaders, fearless on the battlefield and dedicated to ending the tyranny of the Empire. While Leia is certainly beautiful, it is her drive, power, and determination to do the right thing that make her one of the most important characters in the Star Wars universe.

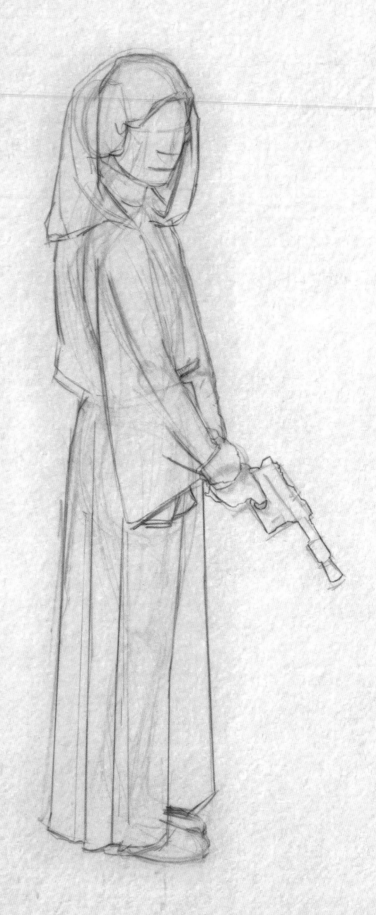

STEP THREE: Clean up and erase the underdrawing. Define the silhouette and tighten the design of her blaster.

STEP FOUR: Add the surface detail. Spend some extra time on Leia's face. Although it is the drawing's focal point, it will be balanced to a certain extent by the black blaster she's holding.

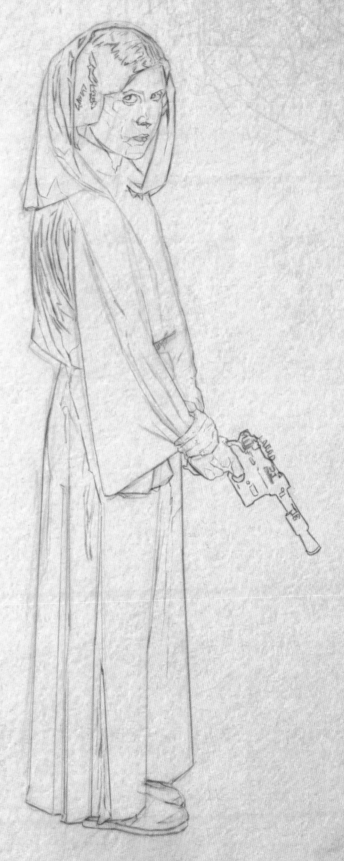

STEP FIVE: Moving from left to right, begin to define the values in Leia's robe and hair, making sure that your pencil strokes move consistently in one direction.

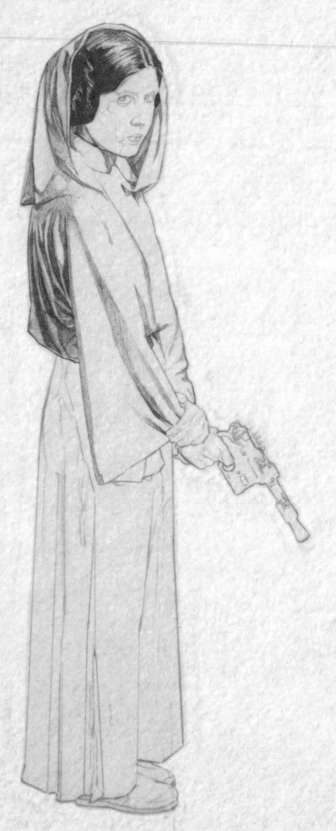

STEP SIX: Add the detail and shadows to Leia's face (more on this on the next page). Although the robe looks white, cover the entire thing with a light, one-directional pencil stroke using a 4H pencil. Also add value to her hands, the blaster she is holding, and her shoes.

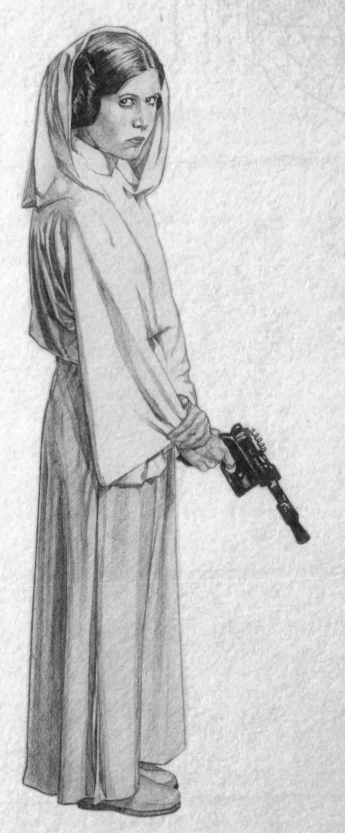

STEP SIX (CONT.): Spend some time adding detail and shadow to the focal point of your piece—Leia's face—using a magnifying lens. Soften any hard edges around her cheekbones.

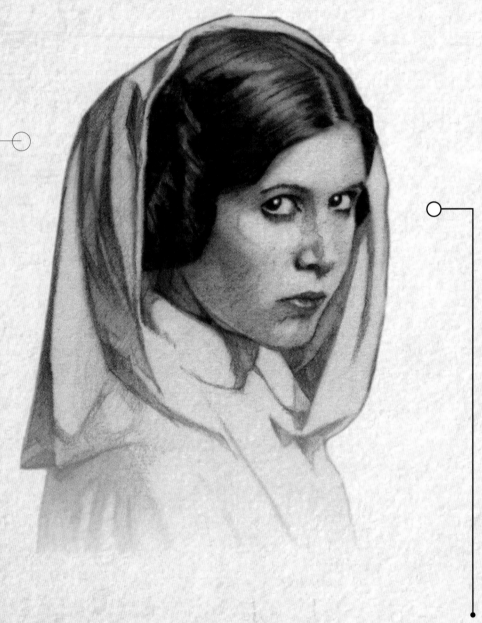

If you have gesso on hand, very carefully add a little sparkle to her eyes with two tiny drops.

STEP SEVEN: Finally, polish your drawing. Go back through the portrait, working in no particular order, smoothing some areas (the face, for instance), and darkening others (her robe, her hair). The sparkle in her eyes, contrasted with her blaster at the ready, shows that while Leia certainly is beautiful, she is prepared to fight on an instant's notice.

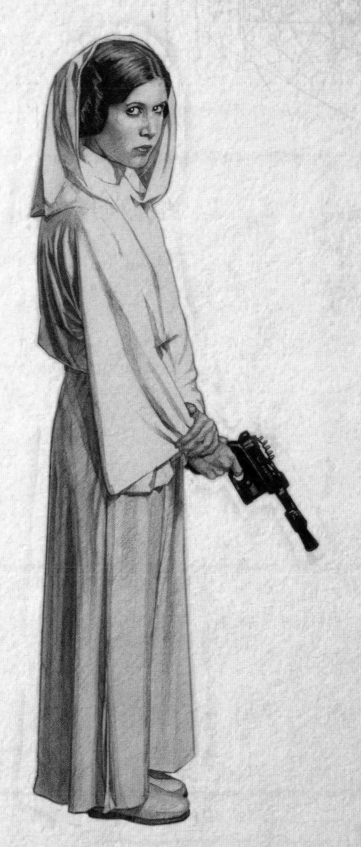

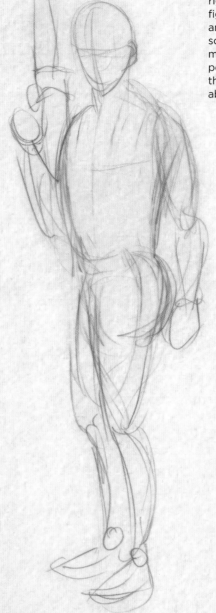

STEP ONE: In this drawing, Luke is standing, slightly twisted toward the viewer, and holding a weapon in his right hand. Begin by drafting a loose figure. Luke isn't particularly muscular, and he's wearing a loose-fitting tunic, so don't worry about defining his chest muscles or biceps. There is a little bit of perspective at work here, so make sure that his right foot is not just behind and above, but a little smaller than his left.

Luke Skywalker becomes one of the greatest Jedi the galaxy has ever known. Along with his friends Princess Leia and Han Solo, he battles the evil Galactic Empire, discovers the truth of his parentage, and ends the tyranny of the Sith. But as depicted in this drawing, Luke doesn't know that yet. Here he is not yet a Jedi, but an innocent farm boy poised to partake in the greatest adventure of his life.

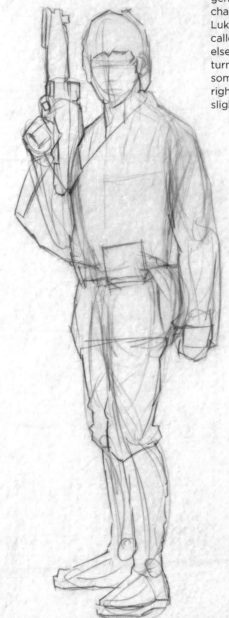

STEP TWO: Begin sketching Luke's tunic and boots. Part of the genius of *Star Wars* is that each character's look is incredibly distinctive; Luke's baggy white shirt and leg wraps, called *puttees*, look like nothing anyone else wears. Note that his left foot is turned toward the viewer and that some foreshortening is required. His right leg is locked, and his left knee is slightly bent.

"I am Luke Skywalker, and I'm here to rescue you!"

STEP THREE: Add more definition and do some general cleanup, erasing most of your underdrawing. Sometimes you can leave initial drawing lines, as it can add texture to the finished work, but because Luke's tunic and pants are almost white, it makes sense to erase the underdrawing in this instance.

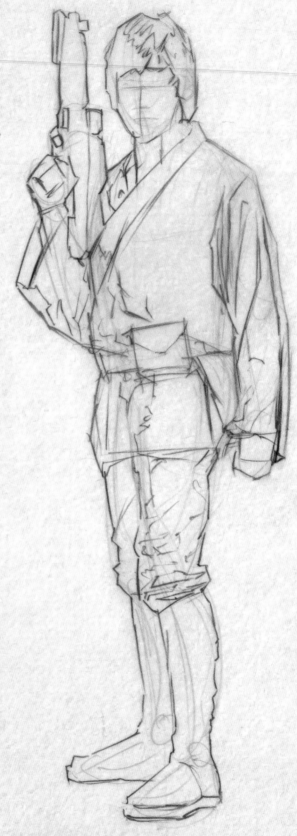

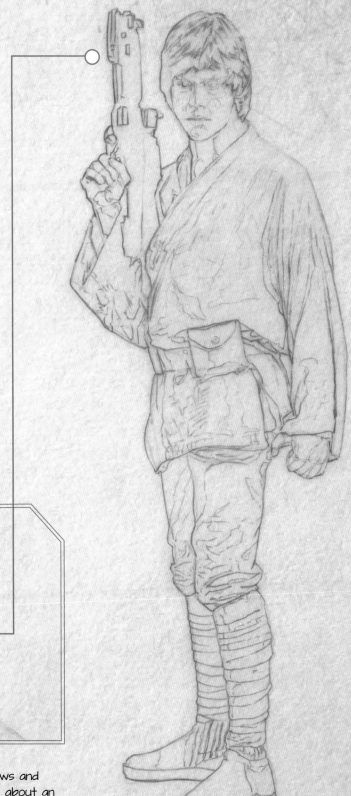

STEP FOUR: Begin the internal linework. Define and outline four basic values. This step is complicated and can be difficult, but there is some room for error.

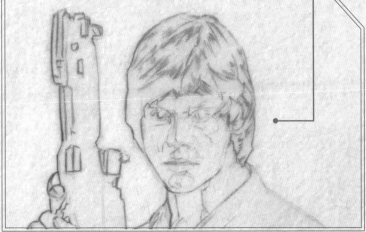

The toughest part in this step is defining the shadows and planes of Luke's face. The facial area itself is only about an inch and a half tall, and the details are relatively hard to see. You can use a magnifying lens to clarify what you're doing. Also make sure that you're working with a very sharp pencil.

STEP FIVE: Add some shading. Complete his hair, leaving in some white areas for highlights. Keep your pencil stokes moving in the same direction; you may need to rotate the drawing surface so the movement of your hand and wrist isn't hindered. On Luke's face, start with the darkest area, his shadowed right eye. Work from that area of darkness to the light area on his left cheekbone. The contrast between light and dark emphasizes Luke's masculine bone structure.

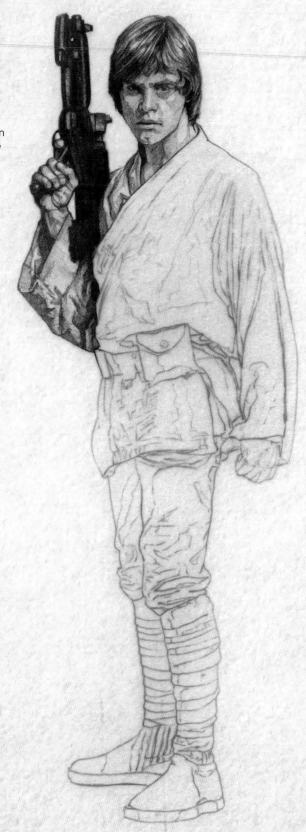

STEP SIX: Moving from top to bottom, shade in more of Luke's tunic. Then define his belt. Use a variety of pencil strokes to define the scratches and distressed marks that make the belt seem well-worn.

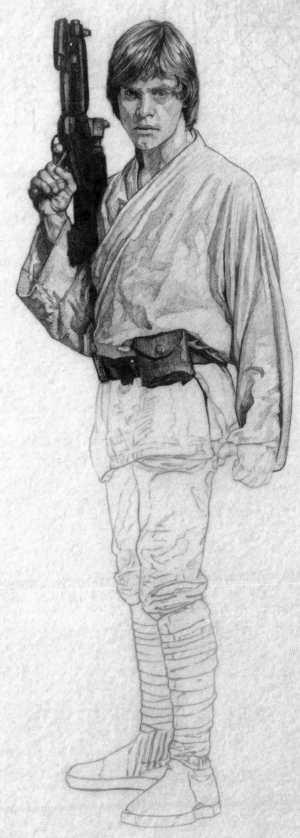

STEP SEVEN: Finish defining Luke's bottom half, and then assess your work. In this particular drawing, there's a good balance of light and dark, and while the texture in Luke's boots, pants, and belt looks good, the shirt and face look a little rough and need to be polished.

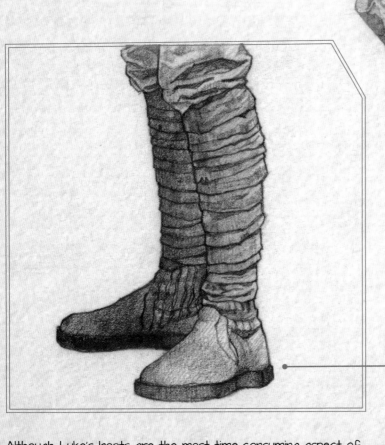

Although Luke's boots are the most time-consuming aspect of this drawing, they're also really fun to draw. Use a lot of up-and-down pencil strokes, varying both pressure and length as you work. After you've finished the individual wraps, go over them with an all-over tone, unifying the look and providing a realistic shadow.

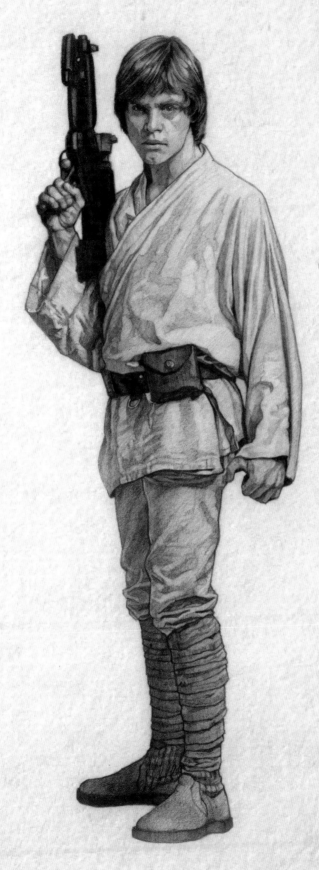

ᛁ↓ᚹᛟ 8

STEP EIGHT: Go over the entire drawing one more time with a 4H pencil. Finally, boost the contrast, darkening some of the shadowed areas. The final image should depict Luke's lingering farm boy innocence but also his determination to restore balance to the Force.

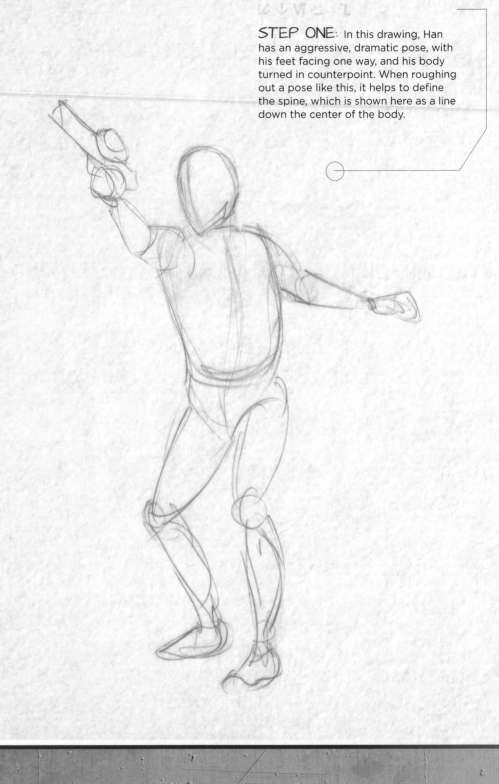

STEP ONE: In this drawing, Han has an aggressive, dramatic pose, with his feet facing one way, and his body turned in counterpoint. When roughing out a pose like this, it helps to define the spine, which is shown here as a line down the center of the body.

Smuggler. Scoundrel. Hero. Han Solo, captain of the Millennium Falcon, is one of the greatest leaders of the Rebel Alliance. He and his co-pilot, Chewbacca, come to believe in the cause of galactic freedom, joining Luke Skywalker and Princess Leia in the fight against the Empire.

STEP TWO: Rough out Han's clothing and accurately locate his face and hair. There's a little foreshortening going on with his left leg and foot, and some slight perspective in his left arm as the bicep recedes from the viewer's eye.

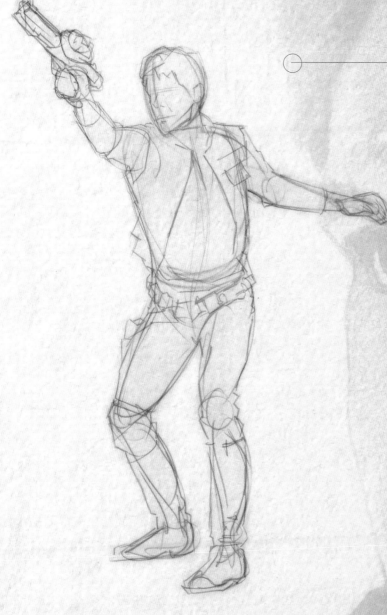

"You've never heard of the Millennium Falcon?"

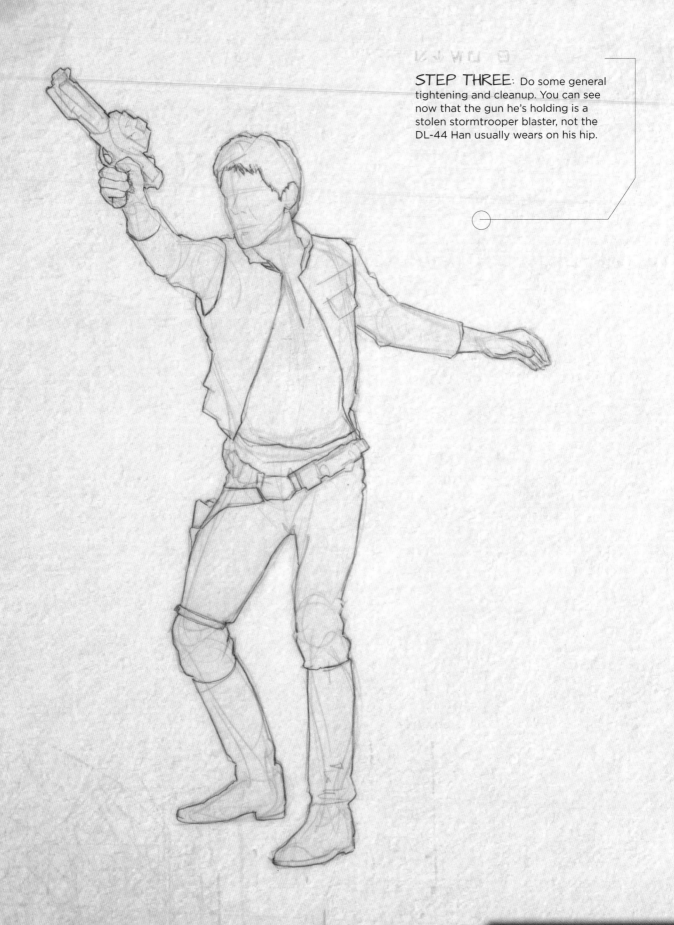

STEP THREE: Do some general tightening and cleanup. You can see now that the gun he's holding is a stolen stormtrooper blaster, not the DL-44 Han usually wears on his hip.

STEP FOUR: As you finish the underdrawing, pay attention to values as opposed to edges. Use a magnifying lens to handle the details in Han's face.

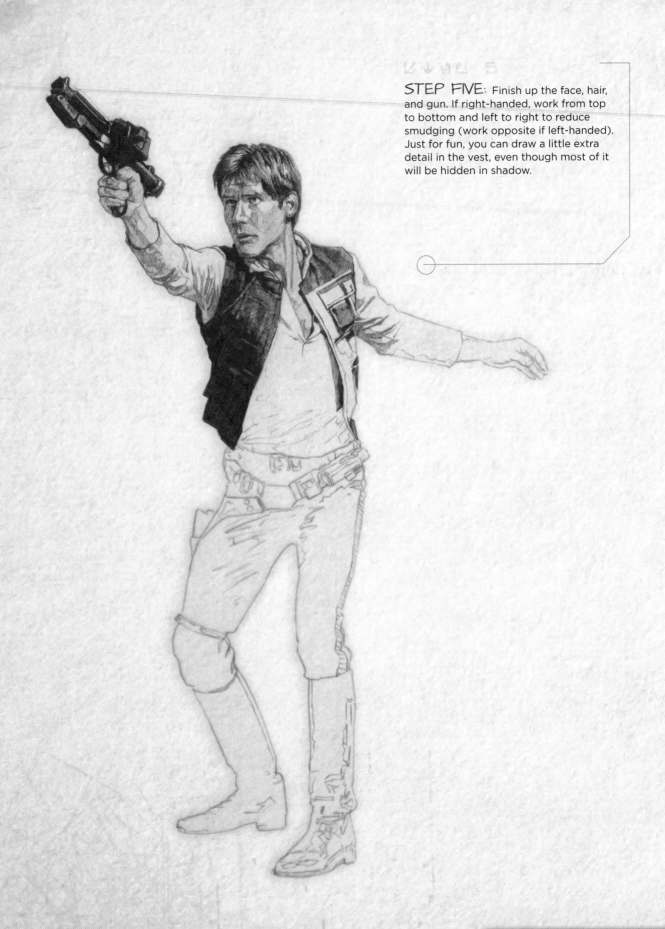

STEP FIVE: Finish up the face, hair, and gun. If right-handed, work from top to bottom and left to right to reduce smudging (work opposite if left-handed). Just for fun, you can draw a little extra detail in the vest, even though most of it will be hidden in shadow.

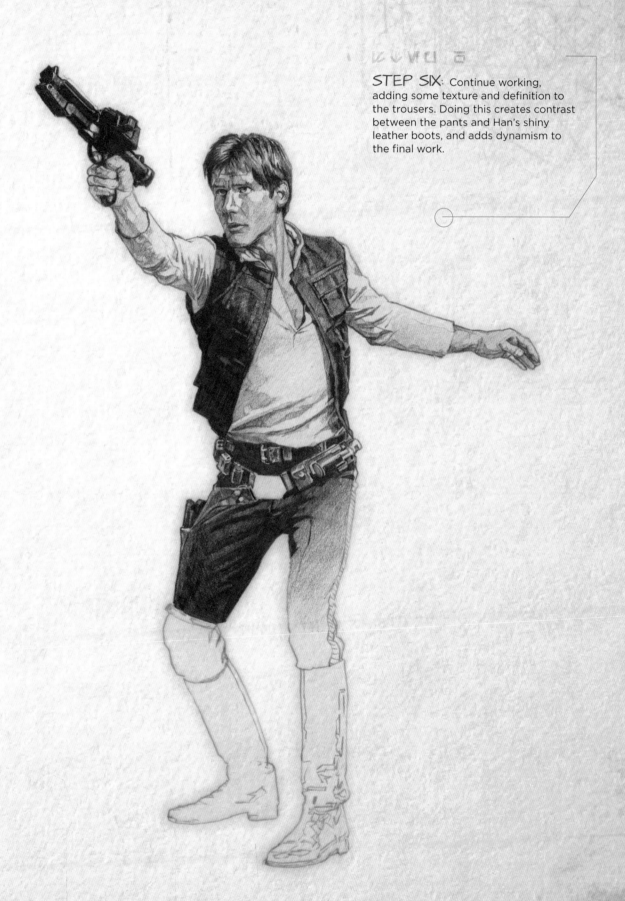

STEP SIX: Continue working, adding some texture and definition to the trousers. Doing this creates contrast between the pants and Han's shiny leather boots, and adds dynamism to the final work.

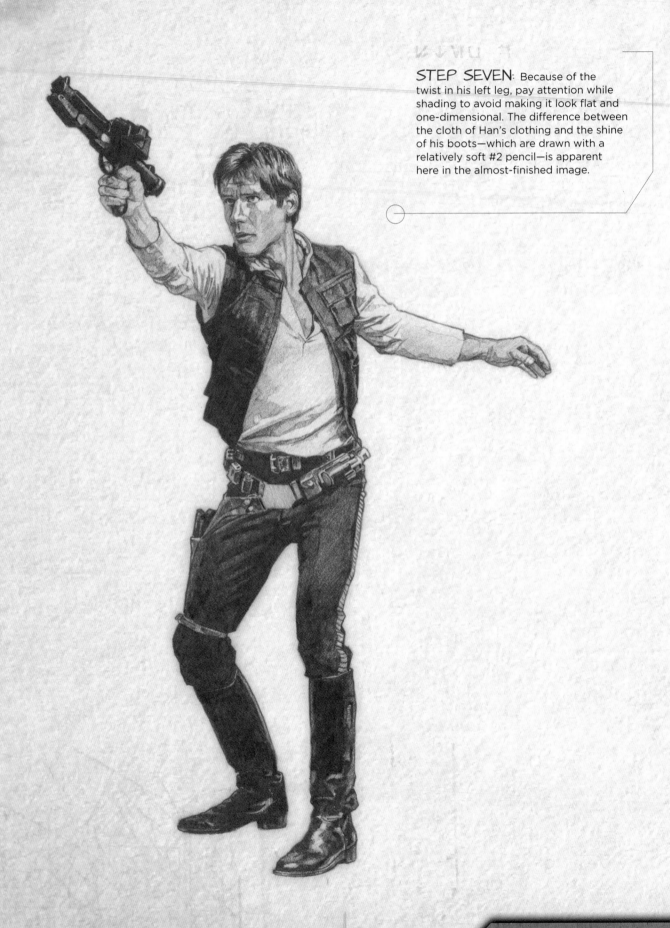

STEP SEVEN: Because of the twist in his left leg, pay attention while shading to avoid making it look flat and one-dimensional. The difference between the cloth of Han's clothing and the shine of his boots—which are drawn with a relatively soft #2 pencil—is apparent here in the almost-finished image.

STEP EIGHT: For the final step, move throughout the drawing, adding some depth and darkness to the shadows and smoothing the shading in the boots. Take this opportunity to do a little repair work to Han's face, if needed. Now that he's finished, we can finally see the heroic scoundrel who stole the heart of a princess and gave his all to the Rebellion.

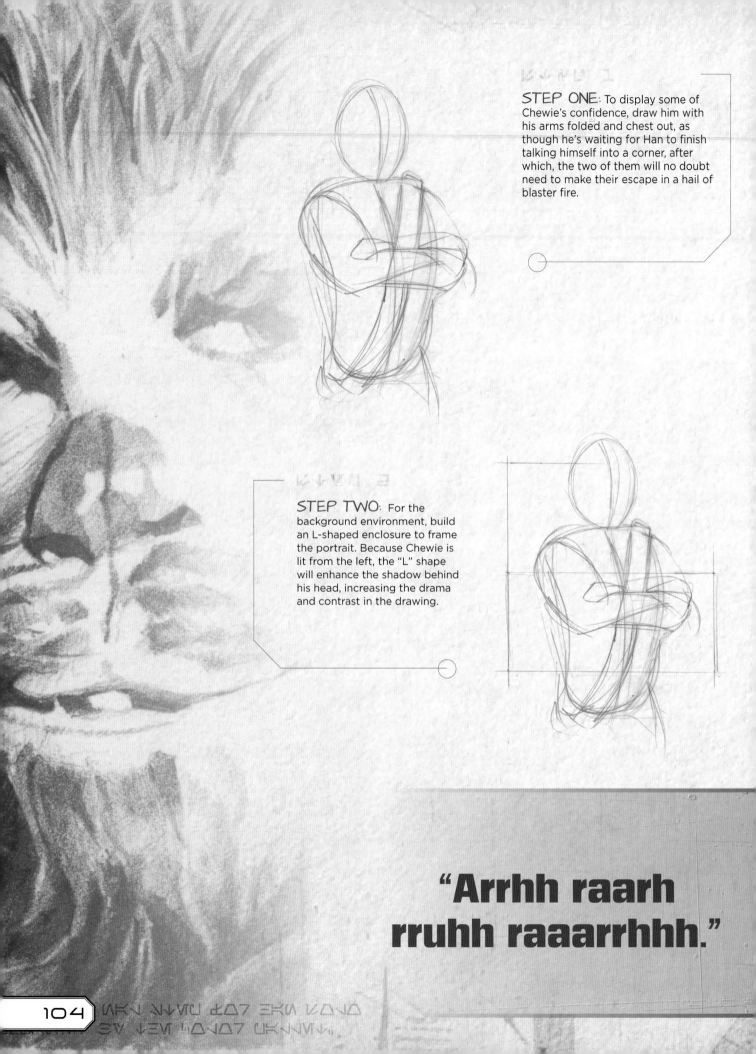

STEP ONE: To display some of Chewie's confidence, draw him with his arms folded and chest out, as though he's waiting for Han to finish talking himself into a corner, after which, the two of them will no doubt need to make their escape in a hail of blaster fire.

STEP TWO: For the background environment, build an L-shaped enclosure to frame the portrait. Because Chewie is lit from the left, the "L" shape will enhance the shadow behind his head, increasing the drama and contrast in the drawing.

"Arrhh raarh rruhh raaarrhhh."

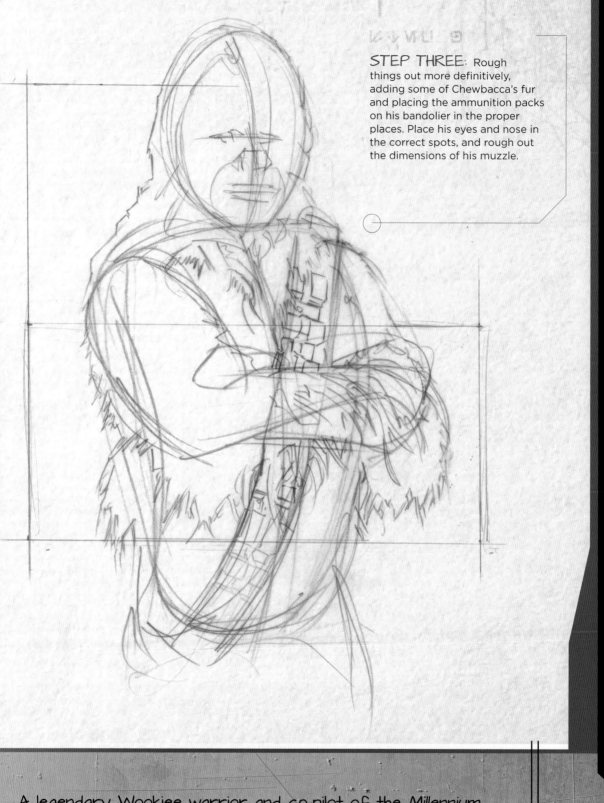

STEP THREE: Rough things out more definitively, adding some of Chewbacca's fur and placing the ammunition packs on his bandolier in the proper places. Place his eyes and nose in the correct spots, and rough out the dimensions of his muzzle.

A legendary Wookiee warrior and co-pilot of the *Millennium Falcon*, Chewbacca is best known for his height and abundant body hair. And while Chewie may be Han Solo's best friend, he's not "man's best friend," and it would be a mistake to depict him as such. Chewbacca has some animal-like characteristics, but he also displays a humanity that makes him one of the most beloved *Star Wars* characters.

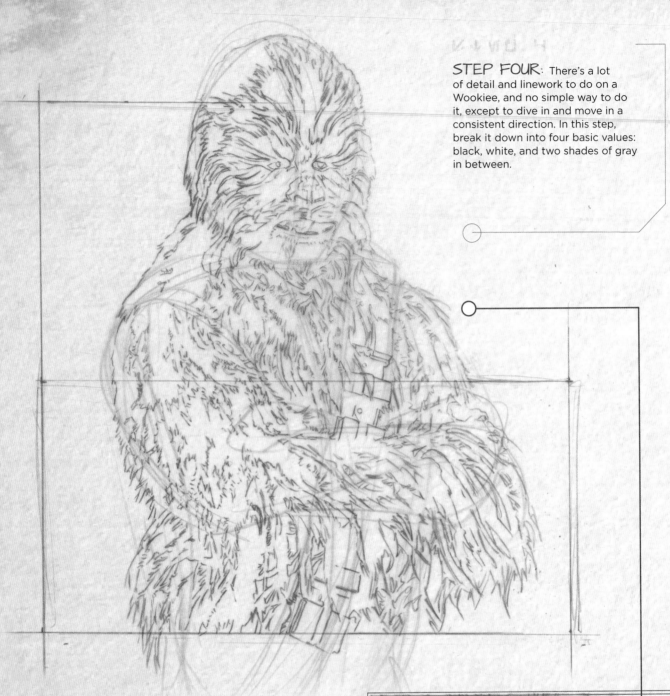

STEP FOUR: There's a lot of detail and linework to do on a Wookiee, and no simple way to do it, except to dive in and move in a consistent direction. In this step, break it down into four basic values: black, white, and two shades of gray in between.

Outline each shape, keeping in mind that you are using shapes to model the figure, as opposed to pencil strokes. Luckily Chewie's hair is so complicated and busy that no one will notice if your finished work doesn't exactly match the original.

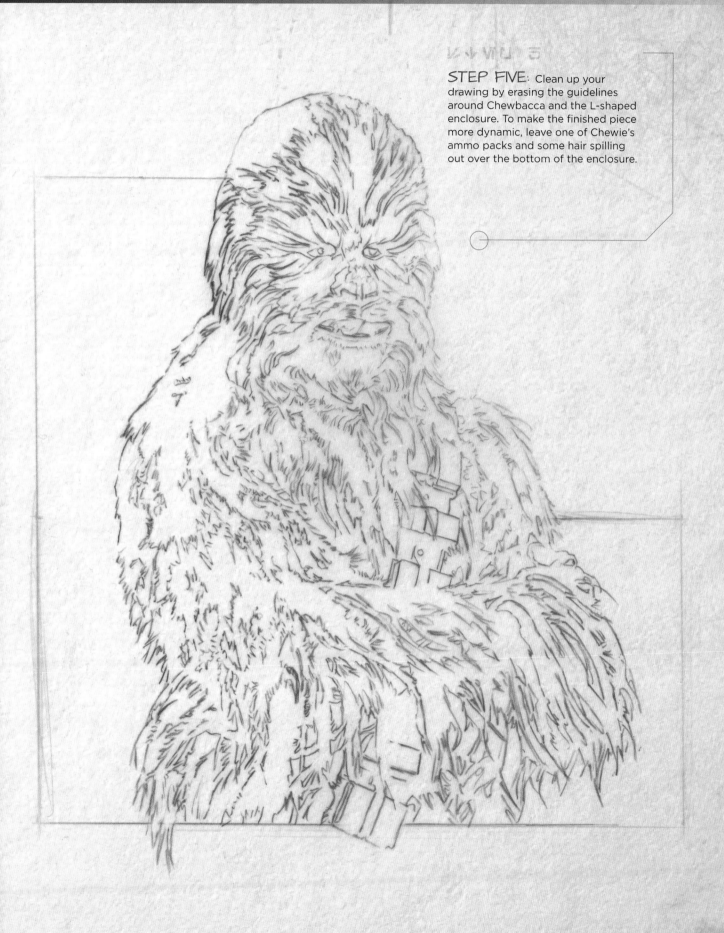

STEP FIVE: Clean up your drawing by erasing the guidelines around Chewbacca and the L-shaped enclosure. To make the finished piece more dynamic, leave one of Chewie's ammo packs and some hair spilling out over the bottom of the enclosure.

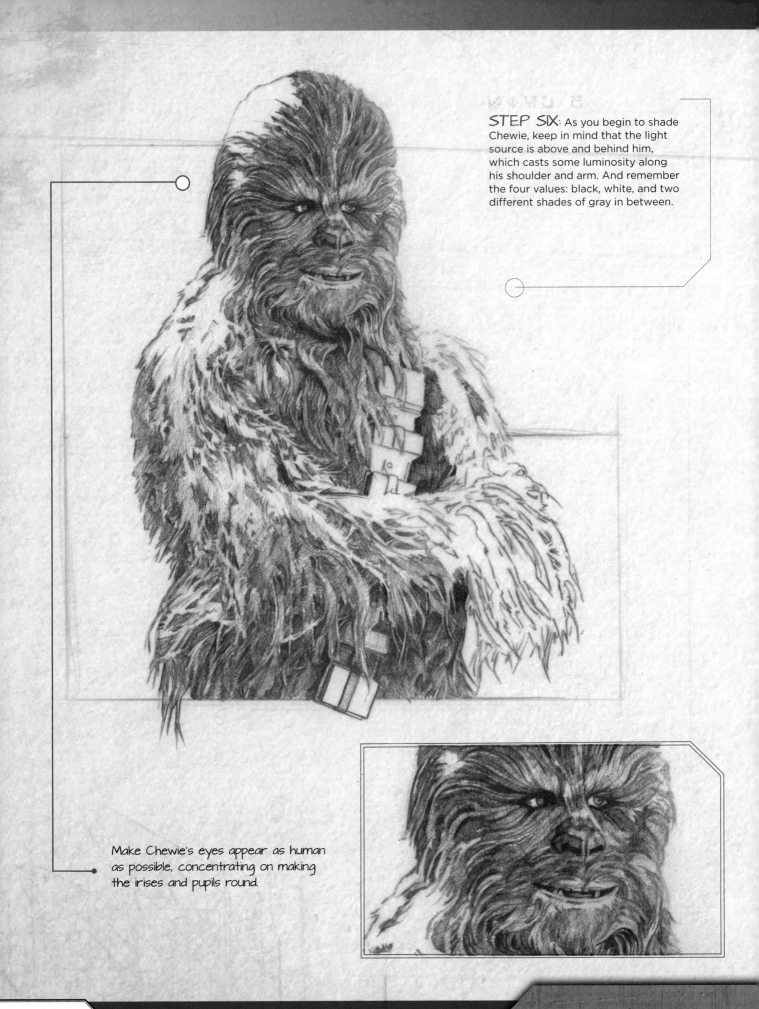

STEP SIX: As you begin to shade Chewie, keep in mind that the light source is above and behind him, which casts some luminosity along his shoulder and arm. And remember the four values: black, white, and two different shades of gray in between.

Make Chewie's eyes appear as human as possible, concentrating on making the irises and pupils round.

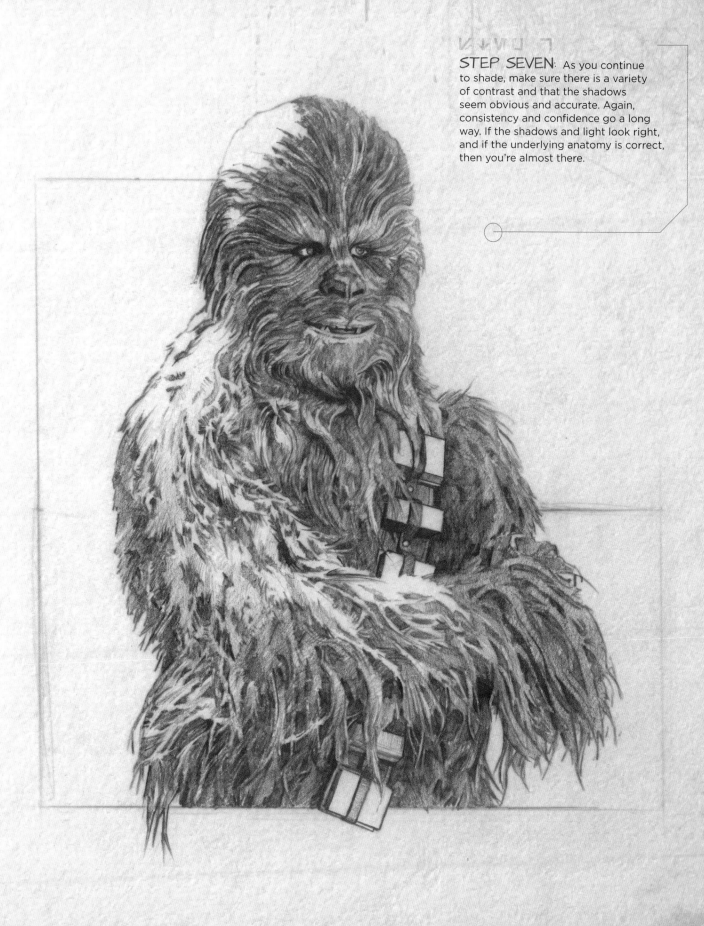

STEP SEVEN: As you continue to shade, make sure there is a variety of contrast and that the shadows seem obvious and accurate. Again, consistency and confidence go a long way. If the shadows and light look right, and if the underlying anatomy is correct, then you're almost there.

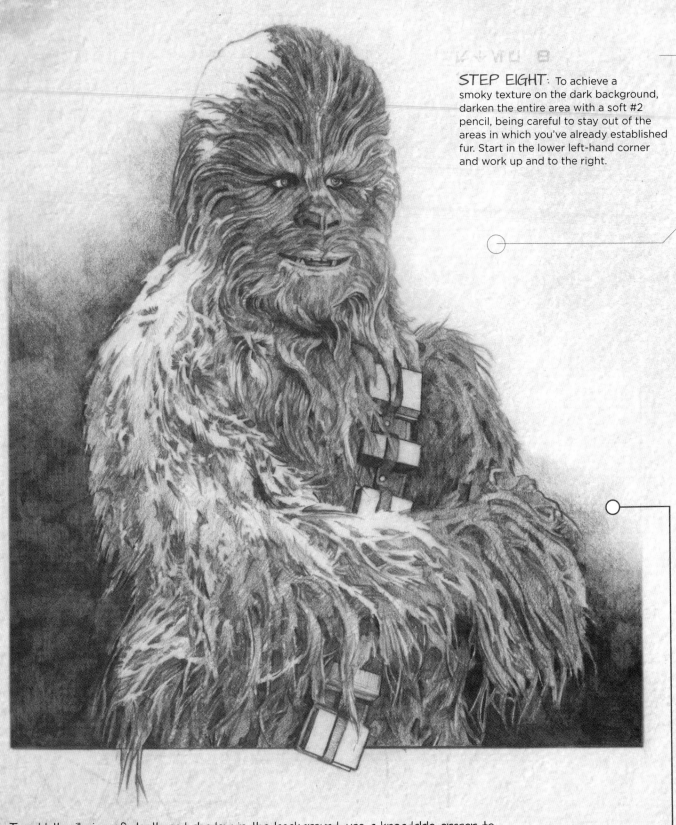

STEP EIGHT: To achieve a smoky texture on the dark background, darken the entire area with a soft #2 pencil, being careful to stay out of the areas in which you've already established fur. Start in the lower left-hand corner and work up and to the right.

To add the illusion of depth and shadow in the background, use a kneadable eraser to dab up various areas of darkness around the enclosure. Then go over the enclosure with pencil again, darkening and blending some of these areas until you're happy with the results.

STEP NINE: Go back into the drawing with a 4H pencil, softening some areas and darkening others. In the finished piece, Chewie's eyes should convey his unique personality and humor, perhaps even reminding the viewer of that little snort of laughter he gives when Leia insults Han in *The Empire Strikes Back*.

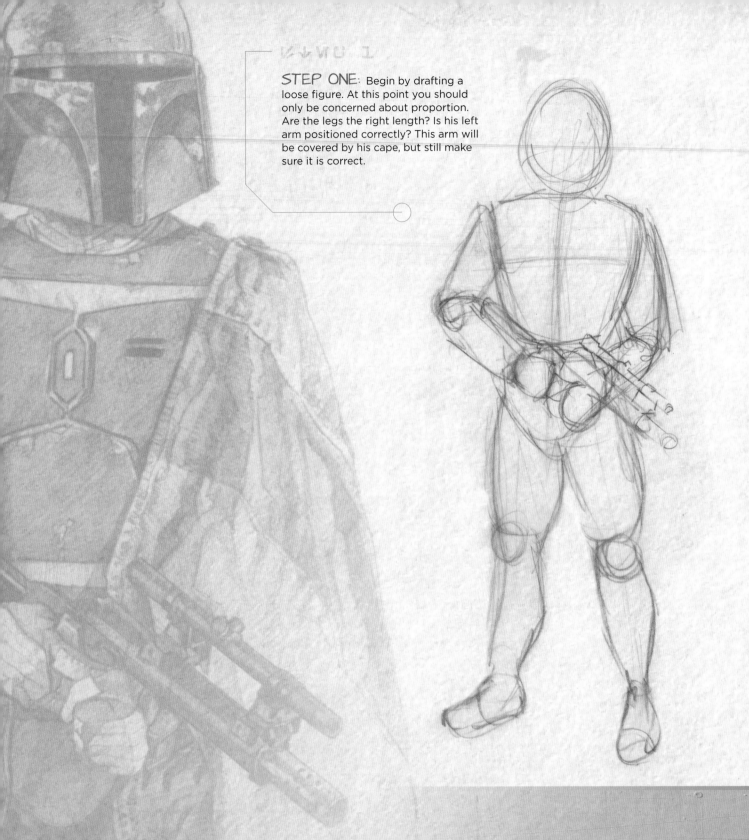

STEP ONE: Begin by drafting a loose figure. At this point you should only be concerned about proportion. Are the legs the right length? Is his left arm positioned correctly? This arm will be covered by his cape, but still make sure it is correct.

"I use any means necessary to get the job done."

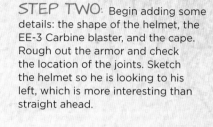

STEP TWO: Begin adding some details: the shape of the helmet, the EE-3 Carbine blaster, and the cape. Rough out the armor and check the location of the joints. Sketch the helmet so he is looking to his left, which is more interesting than straight ahead.

BOBA FETT

Boba Fett is one of the most feared bounty hunters in the galaxy. He is a genetic clone of Jango Fett, so while he is not unique physically, his armor is packed with custom details, such as braids he's taken as trophies and custom paint and decals he's applied throughout his career. Depict these elements, along with the dents and scratches in the armor, but do not allow them to become merely a collection of individual, distracting details.

STEP THREE: Tighten things up and add more detail. First look at it overall, then bounce around the image, doing your best to nail down the things that stand out, either in your reference image or in your mind. The braids hanging off his right shoulder, for instance, are generally tough to see, but because they really add to Boba Fett's individuality, emphasize these—and other similar details—in your drawing.

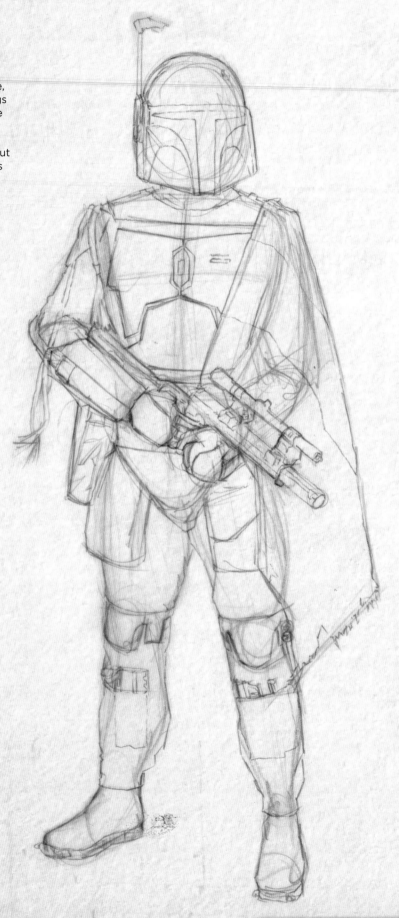

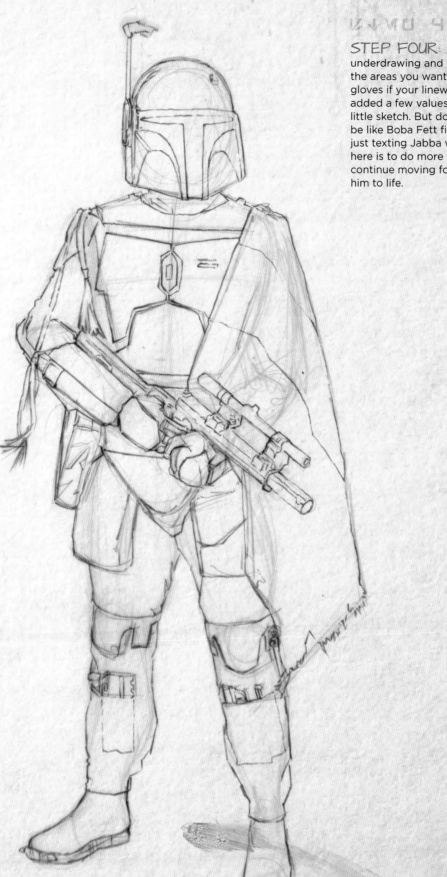

STEP FOUR: Start erasing your underdrawing and work on emphasizing the areas you want to keep. Rework the gloves if your linework was shaky. If you added a few values here, you'd have a nice little sketch. But doing that would sort of be like Boba Fett finding Han Solo and just texting Jabba where he was. The job here is to do more than just a sketch, so continue moving forward to really bring him to life.

STEP FIVE: This is probably the hardest step. Add details and do your best to outline four or five different values as you begin work on the final drawing. There's a lot of squinting involved here. If you half-close your eyes, it helps you see where the various light and dark areas meet.

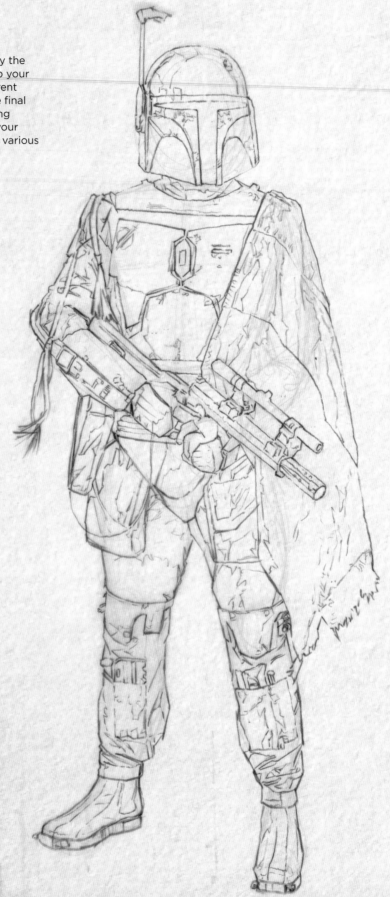

STEP SIX: Now add value. Start shading in the upper left and work down toward the right. Occasionally, you will fill in the darkest area of the image first. Then you'll have both ends of the scale, and it is a little easier to find the middle values. In this instance, Boba Fett's helmet has both black and white tones, so once the helmet is complete, you will have a key for the values in the rest of the drawing.

STEP SEVEN: Add value to the rest of Boba Fett, then all of the major work should be finished. The tones should be even and accurate, and you should have the right balance of detail and generality.

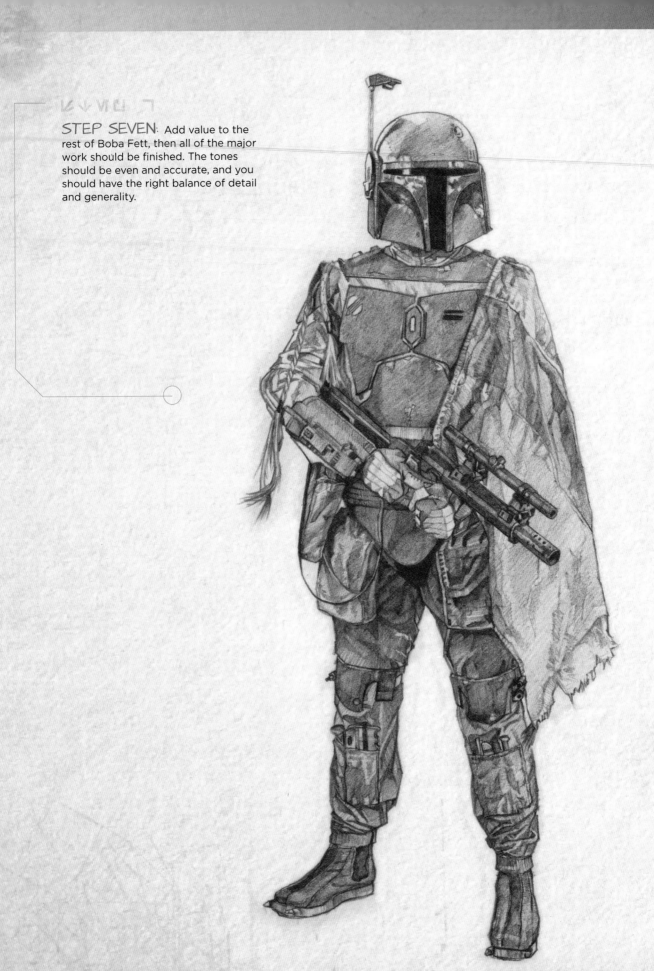

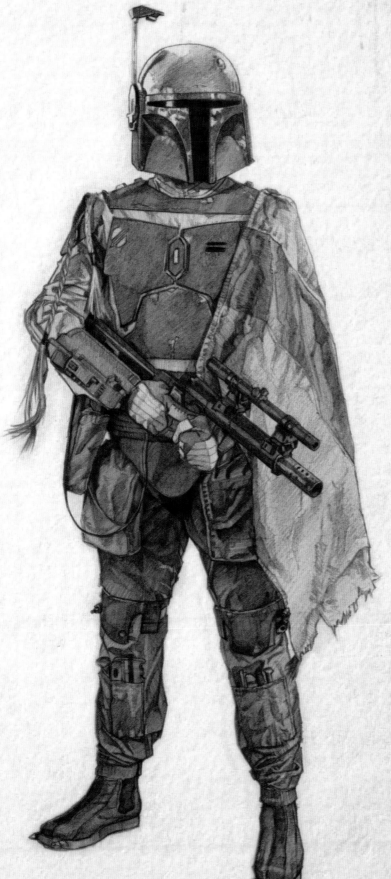

STEP EIGHT: Start at the top and work your way down one more time, tightening areas and blending values together more smoothly. If you use your finger or a blending stick, you will end up with an "smeary" effect. Instead, carefully rework the area with the same #2 pencil you've been drawing with. There are areas, however, particularly the coveralls and armor, which call for a harder-tipped pencil, such as a #4 or 6H. Now you should have a finished piece with even tone, good contrast, and, hopefully, an overall look that says, "Mission accomplished!"

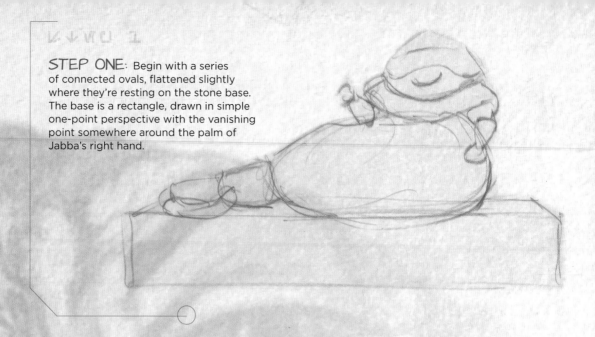

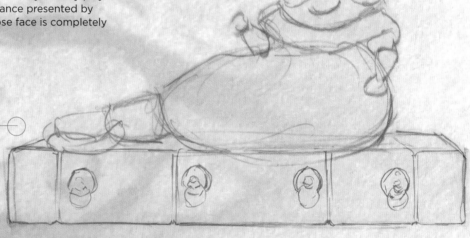

STEP ONE: Begin with a series of connected ovals, flattened slightly where they're resting on the stone base. The base is a rectangle, drawn in simple one-point perspective with the vanishing point somewhere around the palm of Jabba's right hand.

STEP TWO: Add some detail to the stone base and break it into segments. It's OK if you've broken up the stone up unevenly. This touch of asymmetry plays well with the imbalance presented by Jabba himself, whose face is completely asymmetrical.

"This bounty hunter is my kind of scum."

STEP THREE: Clean up the outline a bit, erasing all unnecessary guidelines, and begin working out the details of that ugly, asymmetrical face. Emphasize the characteristics unique to Jabba: the droopy eye, for instance, and the turned-up right side of his mouth.

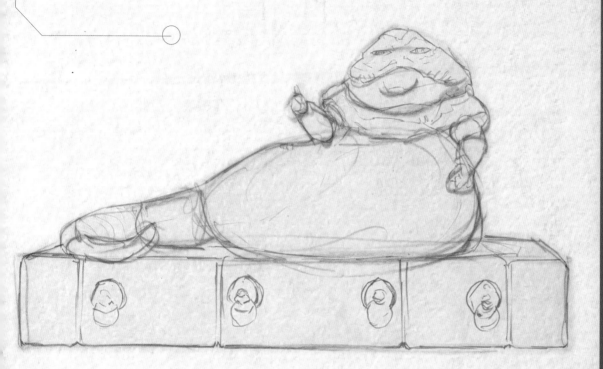

One of the galaxy's most powerful gangsters, Jabba the Hutt has far-reaching influence in both politics and the criminal underworld. Jabba's external appearance is repulsive, and he's just as ugly inside, as he consistently shows off a variety of disgusting characteristics and habits. That said, all his ugly warts and wrinkles are fun to draw, and you'll use some different techniques than usual on this character.

STEP FOUR: Clean up and erase the underdrawing. Keep adding details to the entire drawing and add some detail to the throne and its adornments.

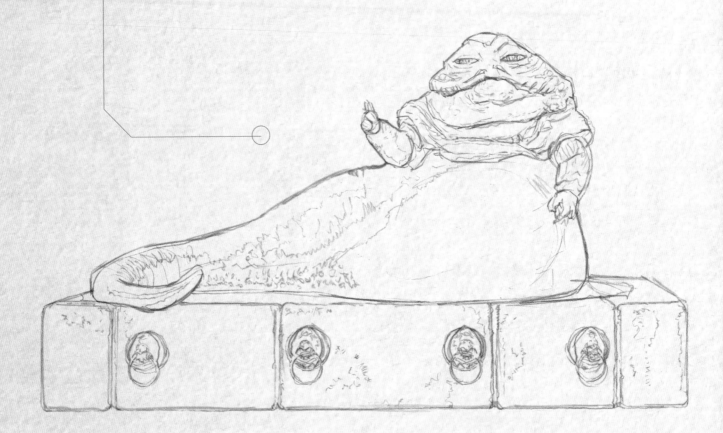

STEP FIVE: Replicating the look of stone is not as difficult as it might appear. As you shade Jabba's favorite resting place, use a variety of different strokes and angles. To avoid the appearance of crosshatching, do your best to stop the lines from overlapping.

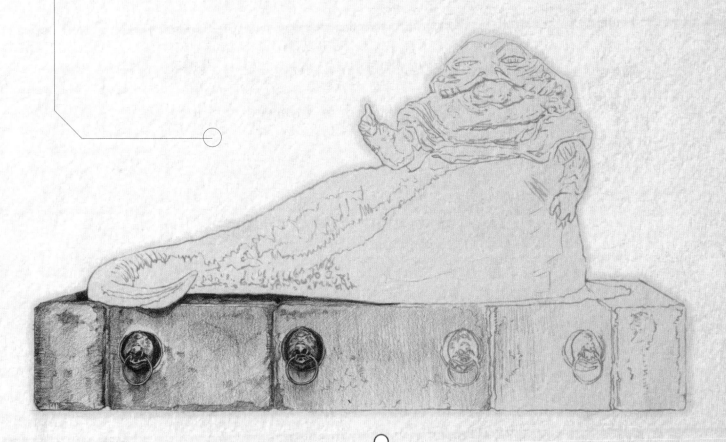

Unless a mistake affects a likeness, or looks exceptionally wrong, just leave it alone. Those little mistakes help make the finished work more organic, gritty, and uniquely yours.

ਟਤਰਯਾ 5

STEP SIX: Finish adding value to the throne. Later, you'll go back and enhance the contrast as a part of the finishing step.

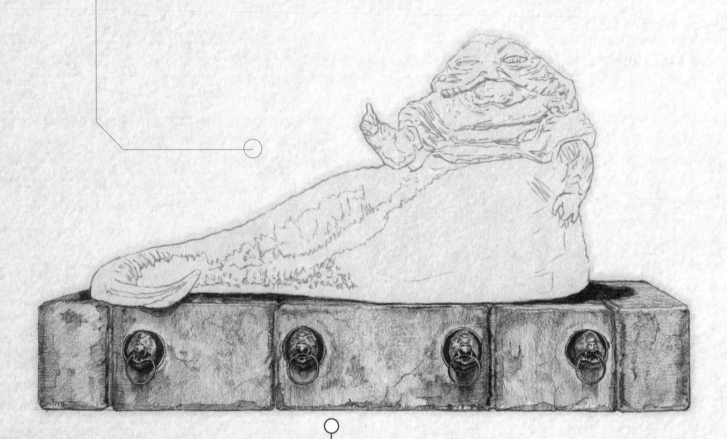

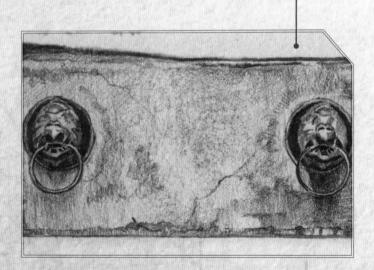

Note the variety of different strokes used to duplicate the look of stone. In addition to the pencil work, occasionally dab a kneadable eraser over the surface to add a blotchy texture. Finish by drawing some cracks across the surface with a sharp pencil.

STEP SEVEN: Working from left to right, add value to Jabba himself. Pay attention to the light source and vary your pencil strokes. Don't worry about the location of every wart and wrinkle. Pay more attention to that as you move toward his face, but for his body, concentrate mostly on light, shadow, and texture.

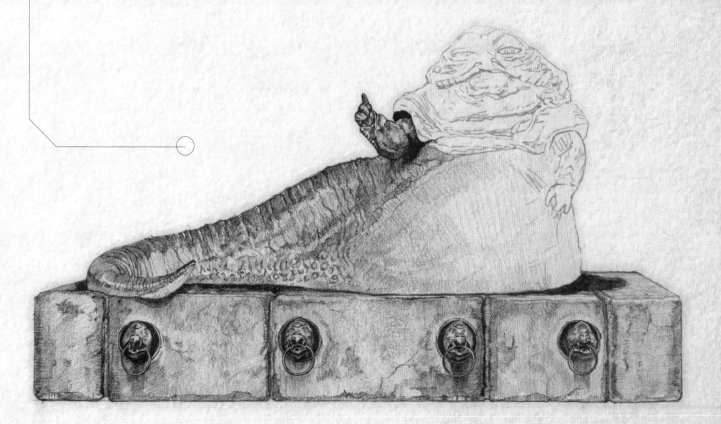

STEP EIGHT: Finish shading. As you work on Jabba's face, make sure that your pencil strokes have a consistent tone and that they're generally moving in the same direction.

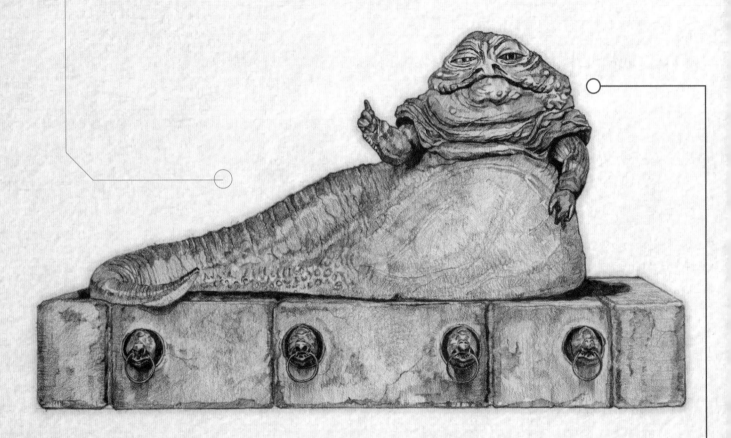

Pay attention to the asymmetry in Jabba's face, and emphasize the wrinkles and bumps that help to make him who he is.

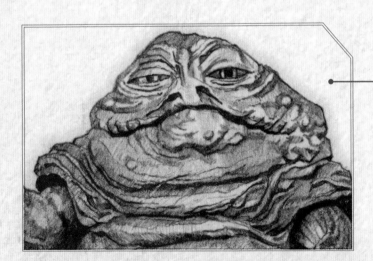

STEP NINE: Finish up by moving through the image with a 4H pencil, smoothing rough spots, emphasizing contrast, and just generally cleaning things up. Use a kneadable eraser to lighten the cracks and scars across Jabba's giant belly.

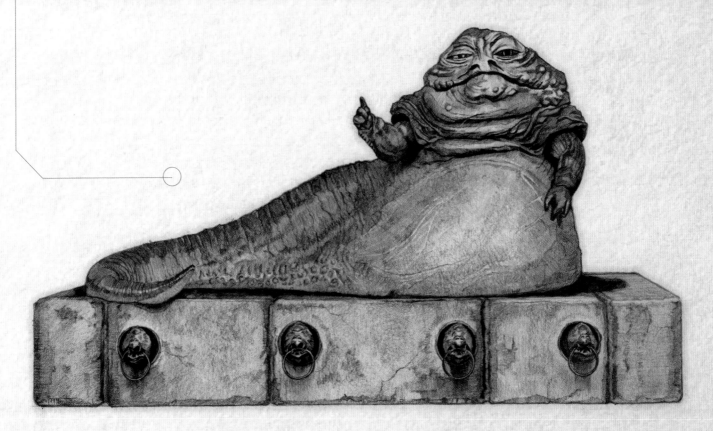

About the Artist

Artist and author Russell Walks made his first *Star Wars* drawing—in ballpoint pen on the back of an envelope—on his way home from the movie theater on a rainy afternoon in 1977. It was a portrait of Luke Skywalker. Or it may have been Han Solo. Some areas around the chin looked sort of like Greedo. Honestly, it wasn't very good, but that didn't really matter because for the few minutes Russell was drawing, while his mom was fighting traffic and his sister was complaining about the rain, he was on the Death Star shooting at stormtroopers and doing his best to save a princess. In the years since that first drawing, Walks has created work based on science fiction and pop culture for some of the largest and most well-known companies in the world. He's also drawn Luke Skywalker about a thousand times. And still, every single time he puts pencil to paper and begins another *Star Wars* drawing, he feels the same sense of wonder and magic he felt on that rainy afternoon in 1977.